MW01059089

DIGITAL MUSIC VIDEOS

QUICK TAKES: MOVIES AND POPULAR CULTURE

Quick Takes: Movies and Popular Culture is a series offering succinct overviews and high-quality writing on cutting-edge themes and issues in film studies. Authors offer both fresh perspectives on new areas of inquiry and original takes on established topics.

SERIES EDITORS:

Gwendolyn Audrey Foster is Willa Cather Professor of English, and she teaches film studies in the Department of English at the University of Nebraska, Lincoln.

Wheeler Winston Dixon is the James Ryan Endowed Professor of Film Studies and Professor of English at the University of Nebraska, Lincoln.

Ian Olney, *Zombie Cinema*
Valérie K. Orlando, *New African Cinema*
Steven Shaviro, *Digital Music Videos*
John Wills, *Disney Culture*

● ● ● ● ● ● ● ● ● ● ● ● ● ● ● ● ● ● ●

Digital Music
Videos

● ● ● ● ● ● ● ● ● ● ● ● ● ● ● ● ● ● ●

STEVEN SHAVIRO

RUTGERS UNIVERSITY PRESS

New Brunswick, Camden, and Newark, New Jersey, and London

Library of Congress Cataloging-in-Publication Data
Names: Shaviro, Steven author.
Title: Digital music videos / Steven Shaviro.
Description: New Brunswick : Rutgers University Press, 2017. |
Series: Quick takes: movies and popular culture |
Includes bibliographical references and index.
Identifiers: LCCN 2016043414| ISBN 9780813589459 (hardcover :
alk. paper) | ISBN 9780813579535 (pbk. : alk. paper) |
ISBN 9780813579542 (e-book (epub)) | ISBN 9780813579559
(e-book (web pdf)) | ISBN 9780813590714 (e-book (mobi))
Subjects: LCSH: Music videos—History and criticism. |
Digital media—History and criticism.
Classification: LCC PN1992.8.M87 S53 2017 |
DDC 780.26/7—dc23
LC record available at https://lccn.loc.gov/2016043414

A British Cataloging-in-Publication record for this book is
available from the British Library.

∞ The paper used in this publication meets the requirements of
the American National Standard for Information Sciences—
Permanence of Paper for Printed Library Materials,
ANSI Z39.48-1992.

www.rutgersuniversitypress.org

Manufactured in the United States of America

FOR ADAH AND ROXANNE

CONTENTS

Introduction 1

1 Superimpositions 19
 Labrinth, "Let It Be"
 (Us, 2014) 19
 Rihanna, "Disturbia"
 (Anthony Mandler, 2007) 27
 Lana Del Rey, "Shades of Cool"
 (Jake Nava, 2014) 38

2 Glitch Aesthetics 51
 Allie X, "Catch"
 (Jérémie Saindon, 2015) 51
 FKA twigs, "Papi Pacify"
 (Tom Beard and FKA twigs, 2013) 59
 Janelle Monáe, "Cold War"
 (Wendy Morgan, 2010) 67

3 Remediations 76
 Animal Collective, "Applesauce"
 (Gaspar Noé, 2013) 76
 Kylie Minogue, "All the Lovers"
 (Joseph Kahn, 2010) 86

Dawn Richard, "Choices"
(Jayson Edward Carter, 2015) 95

4 Limits 104
Massive Attack, "Take It There"
(Hiro Murai, 2016) 104
Sky Ferreira, "Night Time, My Time"
(Grant Singer, 2013) 113
Kari Faux, "Fantasy"
(Carlos López Estrada, 2016) 123

Acknowledgments 133

Further Reading 135

Works Cited 137

Videos Cited 145

Index 147

DIGITAL MUSIC VIDEOS

DIGITAL MUSIC VIDEOS

INTRODUCTION

Music videos are a relatively new media form. Attempts to film musical performances date back to the beginnings of sound cinema in the late 1920s. The first feature-length sound film, *The Jazz Singer* (1927, dir. Alan Crosland), was wildly successful at the box office, in part because it gave audiences the opportunity to see Al Jolson, one of the most popular singers of the time, perform on camera. In movie theaters from the 1930s onward, brief films of musical performances were often presented as shorts before the main feature. There were several attempts—by Panoram Soundies in the 1940s and Scopitone in the 1960s—to create, in bars and cafes, video jukeboxes containing short musical performance movies. The songs in the Beatles' first movie, *A Hard Day's Night* (1964, dir. Richard Lester) are separated from the rest of the action and often filmed as self-contained skits; they stand out as proto-music-videos. The Beatles subsequently experimented with short films to promote some of their singles releases. Queen's 1975 video for "Bohemian Rhapsody," directed by Bruce Gowers, is often regarded as the first music video

proper; it still mostly shows the band performing the song, but it also uses a number of video special effects, such as superimposed images and Freddie Mercury's face cascading in multiple iterations across the screen.

The classical Hollywood musical is also an important precursor of music videos today. Musicals were an extremely popular genre from the early 1930s all the way to the late 1950s. They usually emphasized dancing and singing rather than instrumental performance. From the beginning, Hollywood musicals featured stand-out production numbers, which involved large crews of dancers and singers and which bore only a tenuous relation—if even that—to the plots of the movies in which they were embedded. Busby Berkeley, who choreographed and directed dance sequences for Warner Brothers in the early 1930s and for MGM subsequently, might well be regarded as the first music video director. His productions were extravagant, over the top, and (for the period) sexually risqué. They employed large numbers of dancers, all identically dressed and identically coiffed as if they had emerged from Henry Ford's production line. Their bodies en masse formed elaborate geometrical patterns. They were often photographed by crotch shots that tunneled between the women's open legs or else by shots from the ceiling, so that the dancers arrayed in perfect circles resembled flowers (or perhaps women's genitalia) opening and closing.

Hollywood musicals anticipate music videos in several ways: their emphasis on dance, their use of cinematic techniques and special effects that cannot be replicated in live performance, and their sexual suggestiveness.

The cable station MTV (Music Television), the first platform devoted entirely to music videos as we now know them, started broadcasting in 1981. Appropriately enough, the first video it showed was "Video Killed the Radio Star," by the Buggles (1979, dir. Russell Mulcahy). The song is explicitly about how television replaced radio as the most important broadcast medium in the early 1950s, but it also suggests that music videos might well similarly make audio recordings obsolete. "Video Killed the Radio Star" is thoroughly medium aware; it consciously expresses and illustrates Marshall McLuhan's famous claim that "the medium is the message" (8–9). The video approaches this claim by means of a wacky-nerd aesthetic. For instance, it presents the musicians (Trevor Horn and Geoffrey Downes) as mad scientists. The backup singers (and eventually all of the musicians) appear on a television screen within the video screen. The set is strewn with kitschy electronic media gear, both old and new. The video also shows a young woman dancing inside an enormous test tube. "Video Killed the Radio Star" makes two McLuhanesque points that have remained true for music videos ever since. The first is

that the popularity of music videos means that musicians need to pay attention to visual presentation as well as to sound. The second is that music videos are the product of cutting-edge audiovisual technologies and are bound to change as these technologies change.

My aim in this book is neither to give a rigorous definition of the music video nor to trace the genre's history from 1981 to the present. A rigorous definition is impossible, because cultural categories like "music video" are intrinsically vague, with fuzzy boundaries. There are always ambiguous cases and exceptions to every rule. We can best say about music videos what Ludwig Wittgenstein said about games: there are many "family resemblances" among them, but there is no underlying common essence (35–38). We can also say about music videos what Supreme Court Justice Potter Stewart said about pornography: I cannot define it, he said, but "I know it when I see it." As for the history of music videos, tracing it would go far beyond the limits of this book. For Anglo-American music videos, at least, I recommend the history contained in Saul Austelitz's fine book *Money for Nothing*.

Digital Music Videos is concerned with music videos made in the past decade or so (the earliest video I discuss in depth dates from 2007). I have further restricted its scope to Anglo-American productions, authorized by and involving the musical artists themselves. This is

admittedly a narrow focus. It excludes videos made in different countries and different languages (some of which, like pop from Japan and from South Korea, have recently crossed over to English-language audiences). And it also excludes the rich recent developments in what might be called unofficial music videos: fan videos, mashups, parodies, unauthorized remakes, and so on. My hope is that this narrowness of focus will allow for a greater density of observation and intensity of argument in the book's discussions of particular music videos.

In the thirty-five years since MTV's first broadcast, music videos have gone through many changes. These changes both reflect and themselves contribute to developments in popular culture generally and especially in new media technologies. The MTV era was the golden age of music video; from the mid-1980s through the mid-1990s, production budgets swelled, and videos by major artists like Michael Jackson and Madonna became cultural events in their own right. During this period, the first wave of academic work on music videos was published. This scholarship took it for granted that music videos had to be understood within what Raymond Williams calls the *flow* of broadcast television (86–120). But all this ended in 1997, when MTV stopped showing music videos, replacing them with reality shows as its basic programming format. Around the turn of the century, it

became harder to see new music videos; you could see them on the few remaining video shows on television or in some cases buy them as DVDs. As music videos suffered from reduced circulation, the budgets for making them also sharply declined.

After the founding of YouTube in 2005, however, music videos found a new home online. We could now watch particular videos at will instead of having to wait for them to come up in the course of MTV's overall rotation. At the same time, improving digital technologies made it cheaper and easier to make music videos, even when they included elaborate special effects. Today, music videos once again play a large role in the ecology of popular culture. Unknown bands are eager to make videos for their songs in order to increase their chance of being noticed. And videos by superstars like Beyoncé, Rihanna, and Kanye West are subject to widespread and almost immediate media scrutiny. Just think, for instance, of the controversies aroused by Rihanna's video "Bitch Better Have My Money" (dir. Rihanna and Megaforce, 2015) and by Beyoncé's "visual album" *Lemonade* (dir. Beyoncé and Kahlil Joseph, 2016). The latter is also important for its formal innovation, as it condenses videos for all the separate songs on the album into a continuous movie with a more or less unified narrative. The combination of ever-cheaper digital video production with the ease

of online digital distribution has led, in the past decade, to what might well be regarded as music video's second golden age.

Why analyze music videos at all? On a personal level, I have been a fan of the genre since I first watched MTV in 1981. Working with music videos allows me to combine my enthusiasm as a pop-music fan (despite my lack of musical training) with my more formal concerns as a scholar of audiovisual media. On a more abstract level, music videos fascinate me because they are so complexly overdetermined. Somewhat like Italian operas in the nineteenth century or MGM musicals in the twentieth, music videos are a hybrid, impure form—and indeed a necessarily compromised one. They almost never have the status of independent, self-subsisting works. Even more than other pop-cultural forms, they are subject to the whims of marketers and publicists. They are also generally based on preexisting musical material, which was not created with them in mind. And they most often serve the derivative purposes of advertising the songs for which they were made and of contributing to the larger-than-life, transmedia personas of their performers. In addition, music videos frequently remediate older media contents: alluding to, sampling and recombining, or even straightforwardly plagiarizing material from movies, television shows, fashion photography, and experimental art. This

is a very wide range of references; most viewers (myself included) are not acquainted with all of them. In utilizing so many allusions and outside sources, as well as in focusing on the actual musicians, music videos generally remain illustrative and externally referential—the cardinal sins according to high-modernist theories of art.

And yet, despite all this—or is it rather *because* of all this?—music videos are often deeply self-reflexive and strikingly innovative in form and technique. Like computer games and pornography, they are on the cutting edge of digital technology. They push the latest programs and devices to their limits, and they experiment with new modes of visualization and expression. Precisely because their sonic content already comes ready-made and because they are usually of such a short length, they do not need to conform to older modes of audiovisual organization. They are free to ignore Hollywood mainstays like narrative structures and continuity conventions. Even before the rise of digital sound and image technologies, Michel Chion noted that music videos exhibit "a joyous rhetoric of images," made possible by the fact that "the image is conspicuously attaching itself to some music that was sufficient to itself" (166). Music videos are strictly speaking *superfluous*. If this makes them dispensable and subject to commercial imperatives, it is *also* what gives them a space for free invention.

Recent developments in digital technology have not only led to radical changes in film and video production methods; they have also opened the way to new audiovisual formal structures and styles—or, more loosely, to a new sort of "look and feel" for audiovisual artifacts. Of course, this sort of "look and feel" is far from universal, and there is no necessary correspondence between technologies of production and final products. New video production methods—like neoliberal economic activities in general—are organized on the basis of what Ignatiy Vishnevetsky calls "flexibility and maneuverability." Even when film and video makers are making works that still look and sound like older, more traditional productions, they employ new digital methods in order to save time and money, cut corners, and respond quickly to frequent demands from clients. There are also film and video makers—Michel Gondry is a good example—who exhibit a laudable streak of stubborn perversity, going out of their way to produce works in which digital-seeming effects are in fact created through older, analogue means.

Nonetheless, the new digital technologies and production practices offer new affordances to film and video makers. They open the way for new expressive possibilities—even though such possibilities are often not taken up. As Stanley Cavell puts it in relation to film,

"the aesthetic possibilities of a medium are not givens. . . . Only the art itself can discover its possibilities, and the discovery of a new possibility is the discovery of a new medium" (31). Similarly, the potential expressive uses of today's new digital technologies cannot be known in advance; they can only be discovered or invented, and then elaborated, in the course of actual audiovisual production. At their best, these technologies and practices lead to a new audiovisual aesthetic.

If music videos were already strikingly innovative when Chion was writing in 1990, they are even more fully so today. As Vishnevetsky notes, the chief characteristic of recent digital audiovisual work is that it blurs the line between production and postproduction. Things like framing and focus, which once had to be established at the moment of shooting, are now subject to digital reworking after the shooting is done. Of course, this makes it easier for film and video makers to change their minds and to recast all their material even at the last moment. But these practices also have ontological consequences because they erase the distinction between those aspects of audiovisual material that are actually placed before the camera and sound recorder and those that are subsequently invented, added, or altered on the computer. The very nature of audiovisual construction and reproduction is thereby put into question.

Throughout the twentieth century, the problem of cinematic realism was fervently debated by filmmakers and film theorists alike. Do movies capture reality unvarnished, or are they manipulative constructions? But this whole argument, on both sides, loses its relevance in the digital age. It no longer makes sense to distinguish, as the great film theorist André Bazin once did, between a self-subsistent reality that is indexically captured by the mechanistic recording apparatus of the cinema and an "image," defined as "everything that the depiction of a thing on the screen can add to the thing itself" (88). Rather, these seemingly opposed terms are just the extreme points of what is in practical terms a single ongoing process.

In the twenty-first century, the real itself is continually *in production*—just as Gilles Deleuze and Félix Guattari already intimated in the 1970s. Sonic and visual *material* is always being worked and reworked: in the physical spaces before the camera and sound recorder, in these mechanisms' own processes of capture and transmission, in the digital transformations accomplished through the computer, and in our own subjective acts of perception, reception, and synthesis. All of these processes are equally "real": they are best understood as particular stages in a never-ending adventure of materials. Thanks to recent digital technologies, these diverse stages of actuality now

interpenetrate one another more than ever before. This does not mean that Bazin has been discredited by the nonindexical nature of digital audiovisual capture. To the contrary, he is more in the right than he even knew: "the image may be out of focus, distorted, devoid of colour and without documentary value; nevertheless, it has been created out of the ontology of the model. It is the model" (8).

When I teach "Introduction to Film" (which I do every semester), much of my effort is spent explaining to students the basic formal structures of mise-en-scène, cinematography, and editing. These can be understood as, respectively, that which is presented before the camera, that which the camera itself does, and that which is subsequently assembled out of the material recorded by the camera. Mise-en-scène, cinematography, and editing are crucial categories for film studies, because they refer at once to operations performed in the course of making the film and to formal aspects of the completed film as it is experienced by its audience.

Now, filmmakers have often played fast and loose with these categories, exploiting their ambiguities and loopholes. Long takes by Alfred Hitchcock and Orson Welles, for instance, work to express through camera movement and framing alone what usually needs to be conveyed by means of editing. Jean-Luc Godard's calculated violations of continuity editing rules depend, for their effect,

on our unconscious expectations that these rules will be maintained. But if classical filmmaking established such basic formal categories and modernist filmmaking troubled their boundaries, the most adventurous recent audiovisual production seems to dispense with them altogether. It is not just that there are new ways of putting together moving image sequences during postproduction but also that the resulting sequences look and sound differently than heretofore and are organized by an entirely different logic. For instance, the rapid editing of many music videos bears a certain formal resemblance to 1920s Soviet montage, but the aesthetic aims of contemporary music video directors, no less than their technological means of production, are quite distant from those of Dziga Vertov and Sergei Eisenstein.

Contemporary digital music videos are quite strikingly different, not just from mainstream movies but also from the earlier, predigital music videos of the 1980s and 1990s. Carol Vernallis notes, for instance, how our experience of color in music videos, and of the textures of such diffuse substances as "dust, water, smoke, and clouds," has been transformed by the use of digital intermediate (DI), a process that came into common use only after 2005. Now that color and texture can be controlled and transformed on a pixel-by-pixel basis. Vernallis says, "each element is marked off so clearly it is almost as if we were examining

the video's detail through a magnifying glass" (216–217). Digital compositing already allows for image juxtapositions that are simultaneous, instead of (as in radical cinematic montage) sequential. But DI raises this multiplicity to a higher power, rendering for us something like the perception of machines or of insect-style compound eyes. Vernallis adds that DI also allows video directors to do things like "cut quickly" from "an extreme wide-angle shot" to "an extreme close-up" or "cut three or four fast shots around the face at well-judged off-angles" (218; here she refers in particular to the work of Jonas Åkerlund). These fast edits are generally "hard to see," but they create a subliminal sense of "deeper immersion" for the viewer (218).

Recent digital music videos should also be distinguished from the closely related development of contemporary *chaos cinema* (Stork) or what I have elsewhere called *post-continuity* (Shaviro). I refer to the digitally enabled tendency—especially notable in recent Hollywood action movies—to throw concerns for spatial clarity and causal connection out the window in order to give us instead what Matthias Stork describes as "a barrage of high-voltage scenes. . . . It doesn't matter where you are, and it barely matters if you know what's happening onscreen," as long as you are swept up in the moment-to-moment excitement. There are several reasons why this

is not quite the case for most music videos, even if they freely use the latest digital technologies. For one thing, music videos are not produced to appear on enormous screens, in the way that action movies are. For another thing, music videos are often nonnarrative, and even when they do tell stories, these are not dependent on the articulation of space, time, and causality in the way that they are in mainstream narrative cinema. Music videos, with their brief duration, do not have the time or the flexibility to unfold convoluted plot developments as narrative movies do. But also, because music videos are so short, directors can shape them at a frame-by-frame (or should I say scanline-by-scanline) level, in a way that is not practical for full-length feature films. At the same time, structures that would be confusingly disruptive in narrative films—like alternating between shots the same actor in different locations, wearing different clothes, and with a different look—are entirely conventional and commonplace in music videos. Since music videos are tied to preexisting musical forms, they tend to follow these forms in ways (e.g., verse-chorus structures or repetitions with variations) that traditional narrative movies do not.

Digital Music Videos considers a number of recent music videos that stretch the limits of human experience in various ways. I have tried to combine close formal description of these videos with careful consideration of

their larger cultural and aesthetic contexts. Close formal description is necessary because so many recent digital videos operate on a fine microlevel. They are able to make the most minute sensory discriminations: one hue from another, one grain of sound from another, one pixel or one millisecond from another. These distinctions, like G. W. Leibniz's "minute perceptions" (54–55), fall below the threshold of human recognition and voluntary action. They are *sensations* that do not quite reach the level of conscious *perceptions* (Sparrow). We *feel* them, we are affected by them, but we cannot grasp them or comprehend them. In this way, an inhuman, machinic mode of experiencing is substituted for our own. Insofar as the medium is the message, recent music videos give us an experience of conditions that extend well beyond and beneath the range of our all-too-human subjectivity.

At the same time, it remains important to me that most music videos are not, in fact, avant-garde experiments. Throughout the past century, popular culture and avant-garde culture have influenced each other and indeed borrowed and stolen from each other. But for all the formal experiments and estrangements of popular cinema and pop music, they continue to lay an emphasis on *content* in a way that high-culture artworks often do not. In particular, pop music gives voice to personal experiences of love and hate, sex and desire, anxiety and comfort and rage.

And it explicitly foregrounds all the ways that our lives are affected and shaped by matters of gender, sexual orientation, race and ethnicity, and money and class. Of course, all culture, and all artistic creation, is deeply marked by these structures and experiences. But whereas high culture—not to mention the criticism and theorization of high culture (cf. Theodor Adorno)—generally confronts such factors on the level of form, pop music and pop culture place them front and center on the level of content— and, indeed, most often as crass, vulgar content. I hope to remain true to this approach as well throughout the book.

Digital Music Videos has four chapters, each of which contains close discussions of three recent music videos. Chapter 1, "Superimpositions," discusses three videos that present multiple images at once on the screen, either through false camera movement (Labrinth, "Let It Be") or through the overlaying of different shots that are not composited together (Rihanna, "Disturbia"; Lana Del Rey, "Shades of Cool"). These videos all develop a new, postcinematic language to help the music convey sensations and feelings that do not fit well into conventional cinematic formats. Chapter 2, "Glitch Aesthetics," considers three videos that use new digital media tools disruptively, through violent camera movements (Allie X, "Catch"), loops reminiscent of animated GIFs (FKA twigs, "Papi Pacify"), and undermining synchronization

between sound and image (Janelle Monáe, "Cold War"). These videos enact ways in which new technologies help to provoke new mutations of the human sensorium. Chapter 3, "Remediations," looks at three videos that allude to and transform high-culture visual artworks: flicker films (Animal Collective, "Applesauce"), performance photography and sculpture (Kylie Minogue, "All the Lovers"), and multiprocess photo art (Dawn Richard, "Choices"). These videos illuminate the way connections between high and popular culture are being reconfigured in the twenty-first century. Finally, Chapter 4, "Limits," is concerned with three videos that explore extreme physical and emotional conditions (Massive Attack, "Take It There"; Sky Ferreira, "Night Time, My Time"; and Kari Faux, "Fantasy"). These videos use the resources of new media in order to express and reflect on experiences that cannot even be envisioned through traditional modes of representation.

1

SUPERIMPOSITIONS

The camera pans, in silence, over a bare wooden floor. Spotlights illuminate the floor irregularly. The camera encounters a chair and moves upward, just as we hear the opening minor chord of the song. The tones of the chord are echoed by a voice singing, "I, I, I . . ." Labrinth (Timothy McKenzie) is seated in the chair, a pensive expression on his face, writing with a pencil in a notebook. The camera rises above him, circles behind him, and floats away. After a short pause, a lilting reggae beat starts up, introducing the opening verse. The song is called "Let It Be," but it doesn't seem to have anything to do with the Beatles anthem and album of that name (or, for that matter, with the Replacements' identically titled album). The singer admits in an interview that he jacked the title and that it was "a bit ballsy" of him to do so (Songfacts).

The music video for "Let It Be" is directed by the production duo known as Us (Christopher Barrett and Luke

Taylor). The video consists of a single long take. We seem to be in an empty warehouse or perhaps a large sound-stage. The camera is continually in motion, exploring the space. It glides and hovers; it pushes in and then pulls back; it circles around, twisting and turning; it swoops up to the ceiling and then back down to the floor. In various parts of the space, there are skeletal groupings of fixtures and furniture. Here's a kitchen, there's a corporate board-room, and there's the sound booth of a recording studio. But all of this décor is sketchy and incomplete, without enclosing walls. Each setting is just a mock-up, a bare-bones simulacrum. The fixtures are always surrounded by empty expanses of floor. The camera roams freely among and around them.

We see Labrinth at work in most of these spaces. Some-times he is alone and sometimes with others. Mostly we see him composing and recording the very song we are listening to. He sings into a microphone in the record-ing booth; he plays the guitar while seated on a chair. He rocks the drum set and energetically pounds the key-boards. Each of these is a separate activity, with its own rudimentary set. We also see Labrinth arranging gear in his study, enduring a business meeting and arguing with one of the suits, buying a Rolls Royce, shooting a music video, and being interviewed on a talk show. The compo-sition process involves fatigue and delay, as well as frantic

activity. At one point in the video, Labrinth stands alone in a bleak kitchen drinking coffee, while the sink is already filled to the brim with dirty cups. At another, he has fallen asleep with exhaustion on the living-room couch in front of the TV; his girlfriend unsuccessfully tries to rouse him. There are even a couple of tableaux in which Labrinth himself does not appear. In one of them, a postman delivers mail by pushing it through a slot in a free-standing front door. In the other, an eight-person horn section, all of them wearing white shirts and black pants, stand in a row adding their sounds to the song.

Throughout the video, the camera is always in motion. It never stops, until the very end of the video. For the first minute or so, the camera stays close to the action, showing us only one tableau at a time. But as the video goes on, the camera pulls back and widens its focus, so that several tableaux are visible at once. Labrinth may be singing or playing in the foreground, but we also glimpse other iterations of him in the background. We even see the cameras supposedly being used to shoot the music video and the talk show. By the end of the song, the camera has pulled back far enough that we can see the entire warehouse space at once. As the song builds to a crescendo, the lights go out entirely and then flash on and off several times. Now the warehouse is entirely empty; all the sets have disappeared. Only one iteration of Labrinth is left. The

camera zooms in on him slowly. He stands alone, on the bare floor, in a circle of spotlights, at the spot where the recording booth used to be. Everything else is darkness. The music ends, but the camera continues to zoom in on Labrinth's silent and motionless figure.

"Let It Be" is a beautiful, heartfelt, and highly expressive song. It combines jazzy rhythms with neosoul inflections and even with a suggestion of gospel in Labrinth's booming voice. The music starts plaintively and tentatively, but over the course of three minutes, it builds to a dramatic conclusion. The lyrics suggest a mixture of yearning, struggle, and fatalism. The singer has put out a lot of effort and done his best, but he doesn't have complete control over his circumstances. Effort and hard work can take you only so far. Labrinth has finally reached the point where he just needs to "let it be" and allow whatever happens to run its course. In this way, the song narrates its own process of composition—though its story of effort, struggle, and finally letting go could just as well apply to many other sorts of life experience.

The music video complements the song's reflexivity, by depicting the work involved in its composition and production. We see reenactments of the preparation process, of the actual recording of the music, and even of the song's publicity and marketing. We also get at least some suggestion of the real-life emotions that lie behind the song.

Labrinth says in a supplementary "making-of" video that his aim was to give his fans a sense of what he had been up to in the period before he released the song. He also says that a Rolls Royce was included in the video because he had always wanted to drive one. A whole history—the singer's life, on the one hand, and his specific process of composing, pitching, recording, producing, and releasing the song, on the other—is thus compressed (or, better, seamlessly composited) into a continuous long take, set entirely in a single location. The real star of the video is the motion-control software, which allowed for the computer-controlled execution and precise replication of complex camera movements. All the sets had to be laid out first—together with tracks for the camera, whose route had to be completely programmed in advance. Then, each pass of the camera could capture one tableau or one instance of Labrinth's performance. The software ensured that the separately shot scenes would fit together into a single continuous, and apparently seamless, long take.

Presumably the different events recounted in the video actually happened at different times and in different places. Labrinth had to compose the song before he could record it and finish recording it before he shot a video for it or promoted it on TV. And yet, despite the logical order of these events, the video reenacts them all at once

and places them all in the same location. These events take place simultaneously instead of sequentially. Time collapses into space. The linear thrust of traditional narration is replaced by the circular rhythms and repetitions of the camera's roving eye—and, indeed, of the music. For we hear the song in its final, completed form, even though the video depicts the process of its construction. The elaborate camera movements of the video follow the preexisting rhythms and articulations of the song, with its repetitions, its alternations of verse and chorus, and its intensification to a final crescendo. The overall process is additive—like when a musician layers different instrumental and vocal tracks on top of one another—rather than teleological. In effect, the incidents of the singer's life and the elements of his songwriting process are reordered and recombined by the song itself.

This additive process is also true on a formal and technical level. In traditional cinema, long takes work by substituting camera movement for editing. Filmmakers from Alfred Hitchcock (*Rope*, 1948) to Alejandro González Iñárritu (*Birdman*, 2014) not only give us long sequences of action in a single shot but also disguise their films' actual cuts in order to create an even more prolonged impression of uninterrupted camera movement. The impression is somewhat negated by the fact that—as David Bordwell notes in the case of *Birdman*—the cinematography

often still "adheres to standard editing patterns *within* its long takes" ("Birdman"). But for the most part, the long sequence shot in narrative cinema generally works to capture and render an unbroken block of space-time, corresponding to a single continuous experience of duration. The long take gives us what Gilles Deleuze (himself citing Marcel Proust) calls "time itself, 'a little time in its pure state': a direct time-image" (*Cinema 2* 17). And this pure experience of time is the foundation of the self: for "the only subjectivity is time, . . . and it is we who are internal to time, not the other way round" (82).

However, the long take in "Let It Be" works in a very different manner and thereby gives us a very different sort of audiovisual "image." As Lev Manovich puts it in his pioneering work on digital media, "where old media relied on montage, new media substitutes the aesthetics of continuity. . . . The logic of replacement, characteristic of cinema, gives way to the logic of addition and co-existence" (143, 325). In "Let It Be," editing is not replaced by camera movement so much as by digital compositing. Instead of hidden cuts (subtraction), there are hidden layerings (addition). Multiple images present themselves all at once, rather than one after another. Camera movement, for its part, is entirely mechanized and thereby separated from any sort of inner subjective experience. Far from "adher[ing] to standard editing patterns," the mobile

camera in "Let It Be" seems to function autonomously, on its own account. It roves through the space of the warehouse and observes Labrinth's own emotional ups and downs, but it is untethered to any sort of embodiment or to any particular point of view.

In effect, the camera carves out a new time-volume from an otherwise undifferentiated space. Within this time-volume, events and processes that actually occurred at different moments in different locations are all given to us at once. These events and processes are discontinuous from one another, since they are each displayed separately, in schematized form. And yet these events and processes are all pressed into a unifying global framework: one that is provided by the song itself, as well as by the video's moving camera. They are all happening at the same time—even though they are not instantaneous, in the sense that it takes us a certain amount of time to see them all. In other words, the time of the video—the time it takes for the song to play in its entirety and for the camera to fully explore the space—is a kind of secondary, external time. It is quite different from the subjective, durational time of the events that are depicted and reenacted within the video. That is why we are left, at the very end, after the music has stopped, with the image of Labrinth standing motionless and alone, surrounded by darkness. Letting it be means accepting

vulnerability, by opening myself to a time that is not—
and that cannot be—mine.

RIHANNA, "DISTURBIA" (ANTHONY MANDLER, 2007)

Anthony Mandler's video for Rihanna's song "Disturbia"
takes place in what looks like a Victorian insane asylum.
The set is overstuffed with odd, large mechanical instru-
ments, cages and chains, and various pieces of bric-a-
brac. The overall impression of archaic forms of torture
and confinement is reinforced by the sound effects—
dissonant arpeggios accompanied by creaks—in the first
thirty seconds of the video, before the song proper begins.
My students found the video's décor reminiscent of that
in the computer game and movie series *Silent Hill*, but I
think this is a matter not of homage or direct imitation
but simply of the fact that both works draw on the same
Victorian-asylum imagery.

Rihanna appears in several iterations in the course of
the video. In one guise, she seems to be the director of the
asylum; the rest of the time, she appears as one or another
imprisoned patient. In the former role, she is seated in an
enormous rotating chair. She is dressed in what I can only
describe as Victorian bondage wear: a stiff black dress and
knee-high boots. Her face is made up with heavy dark eye
shadow. Her fingers sport rings and long nails in black nail

polish; the nail polish actually extends beyond the nails, up to the flesh of the fingers themselves. Rihanna turns slowly around in her chair; or she fans herself with one hand, while holding a cigarette in the other. Sometimes she walks about languidly and pats the head of a docile prisoner. In any case, Rihanna is surrounded by a series of doubles or doppelgängers, as well as by strong, menacing male figures. An enormous white man with an eye patch and a black-and-white-striped prison uniform turns a pair of gigantic, creaky mechanical wheels; another large man, shirtless, perhaps a Pacific Islander, beats out the song's brutal rhythm on two enormous drums. While sitting in the chair, Rihanna is also assaulted by her own double: a feral female figure, on all fours, with wrists bound together and a punkish shock of blond hair, who snarls and lunges at her, like a bad pet.

Meanwhile, Rihanna takes on multiple guises as a patient-cum-prisoner in the asylum. In one group of shots, she is caged in a jail cell, with straight blond hair and empty zombie eyes; she violently jerks herself back and forth while gripping the bars. In another group, she thrashes about while chained within an empty bed frame. In still another, Rihanna is splayed out, behind lattice-work, seemingly making love to a life-size male mannequin. Then there is the sequence that suggests a slave auction: Rihanna stands on display, chained to a pillar,

with a collar around her neck, hands tied to a long stick and bound behind her back, and grease smeared on her naked shoulder. During the song's bridge, she is trapped in a room with a low, curved ceiling that prevents her from standing up straight; she pulls furiously on chains that bind her ankles together and rivet her arms to a peg in the floor. Most disturbingly of all, perhaps, we also see a true Lovecraftian nightmare: Rihanna hangs immobilized in a corridor, her lower arms stuck inside the walls and her face covered over by a spiderweb; a tarantula crawls on her upper arm.

Most of these images are composed in murky, gloomy tones, tending toward a monochrome dark blue. The general darkness is relieved by the highlighting of Rihanna's face; her bright red lipstick especially stands out against the darkness. There seem to be electric lights on the ceiling and way back on the far wall. But these lights are generally out of focus and overexposed, so that they appear only as blurry patches, contrasting with the murk but not really cutting through it.

There is, however, one recurring sequence that—in contrast to the rest of the video—is sharply illuminated. Rihanna and a group of backup dancers are silhouetted against a glaring white-and-orange backlight. These dazzlingly lit shots often appear during the first part of the song's chorus: this is when the melody soars and the lyrics

are almost ecstatic, speaking of a wondrous city in which the song's tormented, jealous protagonist risks being lost. The other dancers hold Rihanna's prone body up above their heads, into the light, as if they were offering her as a ritual human sacrifice. Perhaps reinforcing this idea, there are also several orange-lit head shots in which Rihanna seems to be wearing some sort of ceremonial headdress.

The bright backlighting and the group of dancers also appear during the song's "Bum bum be-dum, bum bum be-dum bum" refrain. The music at this point is pounding and inflexible. Rihanna and the other dancers move with spastic, discontinuous jerks of the head or the whole body. Their robotic style responds to the beat's relentless, inorganic regularity. There is no smooth or graceful movement here; everything is shaped by violent constraints.

The images of Rihanna in the asylum are often interrupted by vertical bars or streaks of light. These intrusions have no discernible source within the set. They seem to erupt directly out of the screen, as if they were artifacts of the video apparatus itself. For a comparison, think of the way that so many recent films and videos add lens flare to the image in order to foreground the presence of the camera or deliberately degrade the image in order to suggest archaic recording technologies (like VHS tape or eight-millimeter film). Similarly, in "Disturbia," the streaks of light seem like glitches in the very mechanism

of video reproduction. They draw our attention away from what the images represent and instead toward the mediating process by means of which they are able to be displayed in the first place. The sort of mental turmoil described by the song, which creeps up on people and consumes them, would seem to have infected not only the singer but also the digitizing process.

During the sequence that suggests a slave auction, from about 1:58 to 2:13, flames rise up in the foreground of the image. However, nothing is actually burned by these flames. This is because they do not fit into the same space as the asylum set in which Rihanna herself appears. Rather, the flames ostentatiously belong to what anyone who has ever used graphics software would recognize as a separate image layer. The flames and Rihanna's tormented body are equally insistent as components of the image, but they do not interact. The flames might well be described as what used to be called *nondiegetic inserts*: images that do not belong to the story-world of the movie but instead function as counterpoint, commentary, or metaphor. For instance, in Eisenstein's *October*, the fatuous vanity of Prime Minister Kerensky is conveyed by montage: his image is juxtaposed with shots of a peacock displaying its feathers. "Disturbia," to the contrary, does not show us the flames, which metaphorically consume Rihanna, in separate shots. Rather, they are pasted into

the very scenes on which they comment and whose space they do not share.

This use of multiple layers points up two general tendencies of digital music video. The first is that digital media tend to present simultaneously, by compositing, the figurations that traditional movies used to present sequentially, through associative editing. The horizontal and temporal relation of one image to the next (montage) gives way to the vertical relation among disparate elements presented at the same time (collage). The second tendency is that digital video tends to collapse the distinction, generally upheld in the movies, between diegetic and nondiegetic elements, between story and narration, between naturalistic representations and self-conscious formal devices, and ultimately between what Christian Metz (3) calls statement (*énoncé*) and enunciation (*énonciation*). In all these cases, the two terms are not on an equal footing, because the second is on a higher level (a metalevel) compared to the first. But digital video generally works to break down the hierarchy; different sounds and images are all presented on the same level, regardless of whether they have been actually captured by the audiovisual apparatus (like Rihanna's body) or simulated in software (like the flames).

Of course, digital videos like "Disturbia" continue to use montage (aggressive editing) as well as collage

(compositing). These two devices are not really opposed. They both contribute to the overwhelming proliferation of images in our media-drenched society. Michel Chion, writing in 1990, already suggests that one reason for the radical difference between movies and music videos is that "the rapid succession of shots" in the latter "creates a sense of visual polyphony and even of simultaneity, even as we see only a single image at a time" (166). Music videos are free to be wildly inventive, Chion says, because their images are redundant, since the music already exists before them and without them. But recent digital music videos push this tendency even further than Chion imagined. "Disturbia" moves more deeply into simultaneity by breaking the barrier of just one image at a time. It is polyphonic—or, better, polyoptic—in the way that it continually layers multiple images over one another. Simultaneity (space) replaces succession (time), as is so often the case in digital, postmodern culture. But if the images do not have any time logic of their own, this is because they are subordinated to the rhythmic time of the (preexisting) music.

"Disturbia" is so densely layered, cluttered, and compressed that it seems to require a whole new formal language to do it justice. It would be impossible to make a conventional shot breakdown of this video; images propagate and mutate in ways that do not conform to the

traditional distinctions between mise-en-scène, cinema-tography, and editing. At times, Rihanna's face or figure detaches into two images, one of which jitters and shakes as if it were trying to break free from itself—or as if the camera were having some sort of epileptic seizure. There are also quick movements in and out of focus. Sometimes images are doubled by transparent layering; a detail like Rihanna's face in close-up is pasted over a broader shot of the room in which she is standing. At still other times, barbed-wire and spiderweb patterns are splayed across Rihanna's skin. The video's images fade into one another as well as appearing on top of one another. There is also a lot of rapid cutting, without fades, not only between scenes that show the singer in different locales and wear-ing different costumes (as is common in music videos) but also among fragments of individual scenes or set-ups. Almost everything is presented frontally (as is also a common practice in music videos), but the way that the images are fragmented and multiplied disrupts any stable sense of perspective.

All this makes the video paradoxically feel both unsta-ble and claustrophobic. We cannot escape the asylum, but we also cannot resolve it into a coherent and closed loca-tion. The abrupt dancing, the twitching of the camera, the image juxtapositions, and the aggressive editing all work together to provide a convulsive experience of the

song. Mandler's metamorphosing images do not directly track the formal musical structure of "Disturbia"; there is nothing here so simple as a one-to-one correspondence between image sequences and musical structures. But overall, the images closely respond to the song's shifts of register and its propulsive force. We are sutured into the brutal rhythms of the song, but we also experience a kind of continual displacement. The hyperactive image track leads us to notice different aspects of the sound than we might have done otherwise. In particular, what we might call Mandler's *forcing* of the visuals draws our attention to the song's treatment of Rihanna's voice, with its surprising changes of vocal register from one phrase to another. We do not *hear* the music of "Disturbia" in the same way when we watch the video as we would without it.

The video for "Disturbia" both tracks the music's rhythmic intensities and follows the logic of torment outlined by the song's lyrics. The song is most immediately about mental anguish: the lyrics suggest paranoia, unbearable compulsion, and other such ugly feelings. Rihanna tells us, among other things, that she feels "like a monster." And again, in a line that seems to set forth the visual strategy of the video, "It's like the darkness is the light." I am inclined to give this line its full weight, as a statement of *via negativa* mysticism. The song is an affective expression, but it isn't the *representation* of a mental state. For the very

condition of feelings like these is that they cannot be represented or brought into the light of full consciousness. Rihanna—or her persona in this song—suffers precisely from the absence, and the impossibility, of illumination. And this is the ironic situation that the song and the video strive to "represent."

It is worth noting, in this harsh context, that "Disturbia" was cowritten by Chris Brown, who passed it on to Rihanna after originally having planned to record it himself. Even though the song and video were made and released before the horrific incident in which Brown beat up Rihanna, it is hard to consider "Disturbia" apart from this subsequent history. The lyrics do not explicitly state any cause for the compulsion and paranoia that they express, but these symptoms can easily be interpreted as the effects of jealousy or a broken relationship.

Rihanna has quite consciously presented herself throughout her career both as an active, sexual desiring subject and as an objectified sexual image put on display for a white, heterosexual male gaze. (She's dark enough to be "exotic" but not so dark-skinned as to be overtly menacing to a white audience.) This was already the case in the Caribbean party-girl phase of her earliest recordings. But "Disturbia" marks the beginning of a trajectory that still defines Rihanna's career today. Robin James, writing specifically about Rihanna's 2012 album *Unapologetic,*

discusses the singer's embrace of "melancholic damage" and her absolute refusal of any narrative of recovery and resilience in the wake of the assault. But this "damaged" and willfully unapologetic stance is already evident in "Disturbia." The video's director, Anthony Mandler, who overall has made something like seventeen music videos with Rihanna, says that "Disturbia" marked "the first time she let the world see what was inside her" and that the video "scared the shit out of the label": "I think there was a conversation at one point about shelving it" (Duboff).

In sum, "Disturbia" visualizes an emotional state that is first presented acoustically and that—strictly speaking—is not susceptible to visualization. Pop music is always about the most basic human emotions, at least as they are validated within our culture: love and sex, romance and rivalry, hatred and jealousy, ecstasy and pain. But insofar as the medium is the message, we are now experiencing even these conditions in new ways. The video for "Disturbia" assaults our senses with *too thick* an agglomeration of *too many* images. And yet these all tend to collapse into a black hole of negativity, or a night in which all cows are black. The ultimate effect of the video's profusion is not psychedelic plenitude and certainly not a "joyous rhetoric of images" (Chion 166). To the contrary, the video offers us an amplification of darkness and obliqueness.

LANA DEL REY, "SHADES OF COOL" (JAKE NAVA, 2014)

What does Lana Del Rey want? All of her music impels us to ask this question. "Shades of Cool" is a song from Del Rey's 2014 album *Ultraviolence*. Del Rey's voice flows suavely but plaintively as she recounts her hopeless love for a man who remains distant and is not moved by her charms. She wants to change him, but she finds that he is "unfixable" and that his "heart is unbreakable." There is no way that she can reach him, let alone affect him. But this is precisely what makes him so alluring. Del Rey is desperately attracted to the man's unflappable "shades of cool." The very thing she wants from him is what makes him unattainable. Coolness means detachment and self-sufficiency. A cool person—or so it seems to us—wants nothing and lacks nothing. This means that he is emotionally unavailable. Del Rey desires this man because he seems to be without desire—or, even better, beyond desire.

This emotional dynamic unfolds throughout the course of Jake Nava's video for the song. The celebrated tattoo artist Mark Mahoney plays the role of the object of Del Rey's obsession. He seems to be permanently withdrawn; he is a master of the blank, impassive stare. He is also distant on account of the age difference: Mahoney is fifty-seven years old to Del Rey's twenty-nine. The video

starts with an extreme close-up of Mahoney's face; the camera moves back and forth, scanning his eyes and forehead. The lighting is a soft nocturnal blue. Passing reflections of streetlights tell us that Mahoney is driving and that we are seeing him through the windshield of his convertible. A second shot fades in: the reverse shot, showing us what Mahoney himself sees through the windshield. It's Los Angeles at night; streetlights line both sides of the road, running into the distance. But even as this second shot appears, the first one does not fade away. Instead, shot and reverse shot are superimposed on the screen. This continues until Del Rey starts singing at 0:21. At that point, the video switches to more conventional shots of Mahoney driving his older-model Chevy Malibu. This car is a good vehicle (excuse the pun) for Del Rey's retro fantasies, because it was cool way back in the 1960s and 1970s, when it connoted "weight, power, swagger and testosterone" (Max).

"Shades of Cool" is a languidly paced, downbeat song, in a minor key and 3/4 time. Like most of Del Rey's music, it has a retro feel to it; several critics have suggested that it would not seem out of place in an older James Bond movie soundtrack. The song uses live instrumentation rather than electronic samples; there's lots of guitar, joined by strings in the almost bombastic chorus. Del Rey's voice booms out, covering an impressive range.

"Shades of Cool" follows a typical verse-chorus pattern (AB-AB) but one that is articulated into a larger number of autonomous parts. In greater detail, its organization is Intro-ABCD-ABCD-Bridge-D-Outro. A and B are both verse sections; the first is more straightforward, while the second has a rising intonation. This leads into C, the prechorus, providing a melodic transition. D is the chorus proper; it features a denser drum pattern and thicker instrumentation. The bridge is the most energetic part of the song, with a killer guitar solo that drowns out Del Rey's voice almost entirely. After the final chorus, the outro slows things down. Del Rey murmurs scat syllables, rather than singing actual words.

We see Del Rey herself for the first time only at 0:41, when the song reaches its first B section. Del Rey's figure fades in, over a continuing shot of nighttime Los Angeles. This background is replaced by a blurrier one, perhaps showing foliage (it is hard to tell). Del Rey is wearing a loose white dress, with a pink belt and hair tinted red. She slowly spins around, turning toward us and then away from us again. This is the first of a series of shots that always superimpose the image of Del Rey in white over other images, often dark and blurry ones. Del Rey seems spectral and insubstantial, like a cutout. Her outline even shimmers slightly, with rainbow refractions. Indeed, she

is not actually located *within* any of these scenes. Rather, she is transparent, allowing us to look through her and thereby glimpse hints of another scene, one from which she is absent. As in so many recent digital works, therefore, simultaneity replaces sequence. What distinguishes "Shades of Cool" is that these overlaid images are not composited together. They both appear on screen at once, but they remain entirely separate. They interfere with one another, instead of blending together.

These superimposed images give the video a vague and dreamy feel. Their air of unreality goes along well with the song's melancholy mood. The wavering superimposed images also make a good match for Del Rey's singing style, which oddly seems to be piercing and aggressive and yet also laid-back and passively hypnotic, all at the same time. Del Rey's voice is particularly uncanny in this song, because of the way that she sometimes changes register midphrase. For instance, consider how she sings an important line in the chorus: "I can't break through your world." Del Rey sings the word "I" in smooth higher tones, stretching it out with a melisma that lasts for several measures. In contrast, the rest of the phrase is not only compressed but also sung in a husky, lower register. These changes of vocal tone and the superimposition of fuzzy images on the spectral image of Del Rey both work

to express the song's uncomfortable ambivalence: the fact that Del Rey desperately desires what she also knows will leave her unfulfilled.

From 1:00 to 1:10, as the C section of the song begins, Del Rey's image is superimposed over a daytime shot of Mahoney walking toward the camera, past the Hayworth Theater in Los Angeles's Westlake district. But after this, we quickly return to the spectral Del Rey, superimposed on murky background images, for the rest of sections C and D. There are fireworks, bombs being dropped, and flying birds. At 1:18, at the very end of C, Del Rey looks back at us as the camera moves in on her. She lifts her left thumb to her lower lip, almost as if she were going to suck it. But then, instead, she twists away from us, showing us only her back. The more that Del Rey seems to fade away from us, the more her most minute gestures take on a disturbing erotic charge. These gestures seem, all at once, to be both ingenuously innocent and calculatedly perverse.

There's a shift of imagery as the second verse begins. Starting at 2:03, we see Del Rey, in broad daylight, walking down a palm-tree-lined Los Angeles residential street. This is the first time that we see her image plainly, without overlays. At 2:14, she looks off to her right (screen left). From 2:16 to 2:21, as if in response to her gaze, the camera circles her, with something like a SnorriCam effect. That is to say, it looks as if Del Rey herself is standing still,

while her surroundings spin around her. Del Rey does not lip-sync here, but the camera movement matches the line in the lyrics when she admits that she is only "one of many" among Mahoney's women and shortly before she adds that he may well be looking for "someone new." This shot feels like an important inflection point in the video. Something has crystallized for Del Rey. Her subjectivity takes on a new shape as she recognizes Mahoney's independence from her, as well as his lack of interest in her.

Once the camera stops turning, we see Del Rey's left profile on the right side of the screen. On the left side, we are able to follow her gaze back in depth. Mahoney's Malibu convertible is parked on the corner of a cross-street extending back and away from the plane of the camera. We catch Mahoney in the act of closing the trunk, with his back to us. At 2:24, as the song reaches section B and as Mahoney walks around the car to get into the driver's seat, there's a cut to a shot from the same angle but much closer. The camera then moves in on Mahoney as he turns his head to stare back at it (and therefore also at us and at Del Rey). He offers no sign of recognition but only irritation and impatience. His look implicitly says, "Don't fuck with me." This gaze is not a reciprocal one, of the sort found in the shot/reverse-shot structures of narrative cinema. Instead, Mahoney refuses to engage. He will not turn his encounter with Del Rey into a story.

Following this scene, at 2:30, the video cuts back to the image of spectral Del Rey. Now her image is superimposed over the pinkish traces of what look like the branches of a fruit tree in bloom, together with outlines of flowing water and images of bombs falling. This is the point in the video when the superimpositions are at their thickest. At 2:32–2:33, we also get a brief glimpse of a gun firing, pointing left; afterward, both sides of the screen are filled with smoke. All these dense visual motifs are repeated throughout the course of the video, every time it returns to spectral Del Rey. There is another gun firing, this time pointing right, at 3:43–3:46.

For the rest of section B of the song and then through all of section C and the first half of section D, the video continues to cut back and forth between shots of spectral Del Rey superimposed on murky nighttime images of flowers and explosions and a continuation of the daytime shot of Mahoney opaquely looking back and then getting into his car and driving away. Finally, as the chorus proper begins, the two streams combine, and spectral Del Rey is briefly superimposed over the shot of Mahoney driving away.

In the second half of the song, additional shots of spectral Del Rey, still superimposed over fireworks and explosions, are intercut with two additional series of images. At 3:27, accompanying the second half of the second chorus,

we see the first of several shots of a swimming pool. Everything is bathed in bluish light. Mahoney sits in profile on the right side of the screen, in front of a sort of aquarium window that shows him the underwater expanse of the pool. Mahoney watches as Del Rey slowly swims by from right to left. The camera pans left and upward to follow her course, until Mahoney is no longer in the frame. The video returns several times to shots of Mahoney in front of the swimming-pool window. There are also several shots from the side of the pool, on top, showing Del Rey in the water.

The other new series of images is introduced at the start of the song's bridge, just as the guitar solo cuts in. We are on the sunlit deck or patio of a Los Angeles private house, a "very '70s-styled abode" (Martins). This footage is sometimes—unlike anything else in the video—grainy, blurry, and unsteady, reminiscent of home movies or of the use of a cheap handheld camera. Del Rey is wearing a skimpy red dress. At first we see her dancing by herself, as Mahoney sips a drink and glances back at her with cool disinterest. But then there are a number of sensuous extreme close-ups of Del Rey smoking a cigarette, sipping a pinkish cocktail, and especially—at 4:02–4:05 and again at 4:12—eating a strawberry. The fruit is luscious as she lifts it to her lips and takes a tiny bite, with the camera wavering. Lens flare glistens behind her. From 4:16 to

4:19, Del Rey throws her arms around Mahoney's neck, and they start to dance; it is the first time they have had any physical contact in the course of the video. There are also shots of Del Rey writhing around on the ground, as the camera also moves back and forth erratically. There is far more movement within the frame in these shots than at any other part of the video. These visuals resonate with the buzz-saw guitar solo; both visually and sonically, the bridge is the most intense part of the song.

As the song moves into its final chorus, at 4:32–4:35, there is an extended shot of Del Rey lifting herself smoothly out of the pool, as if she were offering herself to us or to the camera. Her face first shows the signs of physical strain as she pulls out of the water; this expression is then replaced by an earnest look of determination. The outlines of Del Rey's breasts are visible through her wet bathing suit. The sun is blindingly reflected in the water behind her. The next shot is a close-up of Mahoney staring attentively toward the camera. We are not given any hint of where he is standing; the background looks to me like it might be part of the 1970s-style patio. But the play of light over Mahoney's face is consistent with the sunlight reflected off the water behind Del Rey. This close-up of Mahoney is followed by another shot of Del Rey at the side of the pool, still looking determinedly at the camera, until the screen whites out from the dazzle of sunlight.

This sequence, unlike anything else in the video, works as a shot/reverse-shot setup, together with an eye-line match. It stands out as a kind of emotional punctuation, since there is nothing else like it in the video. The continuity rules of narrative film do not generally apply to music videos, which work by a different logic than that of spatio-temporal consistency. Precisely because something like the shot/reverse-shot structure is not needed just to orient the viewer in space, it has much greater weight when, as here, it is used to convey affective relations and tensions. There is finally a suggestion that Mahoney is at least cognizant of Del Rey's desire. It is worth noting, however, that this apparent exchange of looks coincides with, and therefore strains against, Del Rey's singing, in the rousing final chorus, that Mahoney is altogether "unfixable."

When we finally reach the song's outro, at about 5:13, we get a shot reprised from the intro. Once more, Mahoney's face is superimposed over his view from the dashboard as he drives through the night. Everything has come full circle; or, better, it is as if Del Rey's intervening fantasy had never happened at all. After this scene, for the last twenty seconds of the video, we return to the scene of Del Rey dancing with her hands around Mahoney's neck—something we had seen briefly during the bridge and again at 5:06–5:11, at the very end of the final chorus. Del Rey entwines her arms around Mahoney's neck; in

the shot during the chorus, he even reciprocates a bit, by putting an arm around her waist. When we return to this sequence in the outro, the camera is behind Mahoney's back, showing his white shirt and Del Rey's arms encircling him, in such a way that we cannot tell if he is still holding her. Instead, we get a close look at Del Rey's hands: her manicured nails, the large ring on her right middle finger, and the bracelet and tattoo on her left wrist. She still holds a cigarette while dancing. Del Rey and Mahoney turn in a slow circle; or, better, the camera circles around them in slow motion, producing another SnorriCam effect. As before, this effect indicates an inflection point, a crystallization of affect, a change in Del Rey's temperament. She has now reached her climax of delirious self-abandonment; she smiles delightedly, even ecstatically, while Mahoney's gaze remains impassive and perfunctory. Del Rey then releases Mahoney and collapses at his feet. The camera continues to circle around her, unsteadily, from above. She still smiles jubilantly, although her face is not entirely in focus. Even after the music ends, the camera continues to rove over Del Rey's prone body for a few additional seconds.

And that is all—or almost. Shortly after the video was first released, Jake Nava posted an alternative "director's cut" on his own website. It was taken down shortly thereafter, but it can still be found online. There are only a few

differences between the two versions; the most import-
ant one is a single shot in the director's cut, from 4:56 to
5:06, that shows Del Rey underwater, with her arms and
hair trailing upward, floating inertly toward the bottom
of the pool as if she had drowned. This is just at the end
of the song's final chorus and after the shot/reverse-shot
sequence in which Del Rey emerges from the pool. In the
official version of the video, the drowning shot is replaced
by a reprise of elements that we have already seen: spec-
tral Laura, Mahoney sitting by the aquarium-style win-
dow, and Del Rey dancing with Mahoney. The drowning
shot resonates with and gives heavier importance to the
superimposed images of guns firing and bombs drop-
ping. It has been suggested that the director's cut was sup-
pressed because, just at the time the video was released,
Del Rey came under heavy fire in the press for telling an
interviewer, "I wish I was dead already."

What can we make of this added shot? Even though
the drowning shot makes things more explicit, the video
already has a downward, depressive trajectory even with-
out it. I am inclined to be wary of efforts to narrativize
music videos, as if their complex editing structures could
be reduced to linear order. The musical time of a song,
involving diverse rhythms and reprises, is not the same
as the linear, narrative time of a causally connected series
of events. In any case, the video ends in either version

not with Del Rey drowning but with her letting go of Mahoney and falling, whether tipsy or exhausted, to the floor. In "Shades of Cool," Del Rey wants to be possessed. But she discovers that she cannot be. She is attracted to cool, world-weary, aging hipsters, like Mahoney in this video, but the very terms of her fantasy guarantee that it can never be fulfilled. She tries to live in a retro time warp, by reviving and inhabiting the languorously passive models of pre-second-wave-feminism femininity, but she inevitably fails at doing so. The past continually haunts us, and we cannot simply wish it away. But we cannot live the past again either, and for the very same reason: it would require the making substantial of something that is only a haunting. Del Rey's ideal lover may "live in shades of cool," but she herself cannot ever get there.

2

GLITCH AESTHETICS

Jérémie Saindon's music video for Allie X's "Catch" is a surrealist assault on the senses. We see Allie X in numerous discomfiting poses, all within a sleek, minimal, faux-modernist space; the different shots of different rooms alternately suggest a condo residence, a musician's studio, an art gallery, and perhaps even an empty indoor swimming pool. Allie X is the only actual person in the video. She appears both as an artist or creator and as a work of art. Often we see her standing on a rotating pedestal, in front of a keyboard. But at other points, her body hangs suspended from the ceiling, as if on exhibit, pierced by many long spikes. At still other points, she stands nude on a pedestal like a sculpture on display, with her hair draped entirely over her face.

We also see Allie X entangled in a pile of intertwined, and seemingly inanimate, nudes; only her head emerges from the confusion. In other shots, she lies splayed out

on a dissection table; most of her body is replaced by a life-size plastic anatomical model that opens up to display replicas of the internal organs. And once, at about 2:55, her body appears strewn across the floor, sliced into four separate parts—head and torso, midriff, thighs, and lower legs—all of which are twitching on their own. At still other moments, Allie X stands naked except for a sort of white veil or headdress, extending upward in a cone and completely covering her face. There is just one opening in the headdress, for her mouth; a disgusting viscous white fluid oozes out from it. Then there are the shots in which she is sheathed in a burgundy-colored dress (or perhaps a sheet); her face is replaced by a group of prisms. And in still other shots, Allie X lies on the floor surrounded by overlaid still images of butterflies. At the end of the video, another butterfly emerges from a sort of metallic cocoon in her mouth and flies away.

The video is also deeply concerned with eyes and with vision. In many shots, Allie X wears sunglasses or else eyeglasses whose lenses have been replaced by a dense, pink, flowery growth. This is consistent with Allie X's previous videos and art projects, in the course of which the singer "never . . . revealed her eyes" at all (Rickman). At certain points in the "Catch" video, Allie X finally does unveil her eyes to the camera. But these eyes don't stare soulfully out at us. Rather, they blink rapidly; or else they glare

or ponder without expression. There are several shots in which Allie X lies on a couch, wearing a leaf-print onesie jumpsuit; she looks toward a replica of herself reclining on the floor, whom we see from the back. Then she closes her eyes and opens her mouth wide; she is holding a replica eyeball between her lips.

I am reminded, of course, of other surrealist aggressions against vision, starting with Luis Buñuel's razor slicing an eyeball in *Un chien andalou* (1929). The Surrealists were also obsessed with the nude female body, which they often depicted dead or dismembered or bound in abject poses (think, for example, of Hans Bellmer's dolls). Allie X *détourns* these surrealist tropes for her own ends. Although her body is mutilated and abjected throughout the video, it is not presented as a spectacle for some sadistic, controlling "male gaze." Rather, Allie X clearly remains in control; she positively *assaults* us with these grotesque body images. Even when she is naked, we are denied access to her body and her eyes. However uncomfortably near to us this body comes, and even as it is literally and metaphorically opened up, it remains entirely opaque and unreadable. The circuit of the gaze between her and us is blocked, even when her eyes are visible.

In the video, Allie X only lip-syncs occasionally; her efforts to do so are deliberately formulaic and desultory. Because of this effect, her voice does not seem to

be grounded in her body; even when it soars, during the chorus, it is just another layer of the electronic mix. Allie X's singing is expressive but also at the same time oddly detached. On all levels, and despite the music video's aggressive display, it refuses contact. We are able neither to identify with Allie X nor to objectify her as a sexual figure. We are made all too familiar with her agitation and distress, but at the same time, she denies us any intimacy.

The video picks up all these qualities from the song itself. "Catch" is a synth-pop tune. It is bouncy and propulsive, but it is not warm. With its throbbing, repetitive rhythm, it walks a thin line between mechanical repetition and gleefully upbeat expression. One reviewer aptly describes the song as "a relentless and immediate sugar rush with a slight metallic aftertaste" (Pagnani). The lyrics speak of being victimized by a lover who toyed with the singer's affections, devastating and then abandoning her. But the song does not wallow in romantic lament. It's too fast and jittery for any such sentiments. Rather, Allie X compares her sexual obsession to heroin addiction. She is suffering from withdrawal. But she doesn't want to get clean; rather, she hopes only to find a more reliable source for the drug that takes away her pain. In the song's coldly exultant chorus, Allie X promises revenge on her betrayer with the repeated phrase "just wait until I catch my breath."

I still haven't mentioned the most intense and pow-
erful thing about the music video, which is its relentless,
jittery visual rhythm. The image is never still. Nearly
every sequence consists of images that flash back and
forth between two stills like a stuttering repetitive jump
cut or that quickly loop back and forth like an animated
GIF. And indeed, Allie X has posted a number of ani-
mated GIFs derived from the video on her Tumblr. Upon
close examination, the organization of the video is quite
complex. Sometimes the entire image loops; sometimes
the looping figure is composited into a background that
remains still or that loops with a different rhythm. Some-
times the looping figure moves around in a circle, while
other times it jerks back and forth; and still other times
it just twitches faintly. Then there are the times when
Allie X's figure does not itself move; but the camera pans
violently one way and then the other, or the background
flashes from one configuration to another and back again,
or two separate images are alternated rapidly.

The video thus renders for us a world in continual agi-
tation. The motion is sometimes more violent and some-
times less; it is sometimes more all-embracing and other
times restricted to a few figures. But the image is never
completely still. Even in the last few seconds of the video,
when the singer and the camera both finally stop moving,
we are transfixed by the flight of the butterfly that emerges

from Allie X's mouth. The video for "Catch" is in constant, tumultuous motion, even though it doesn't *take us* anywhere but keeps on returning to the same few visual tableaux. It is almost as if the video were extending our vision beyond the human scale, by making perceptible to us the incessant molecular turmoil that underlies even the most stable objects. The singer's subjective feelings of agitation, the agitations of the video apparatus, and the objective agitations of the physical world are all of the same nature. At this molecular level, there can be no stable phenomenology. Our common dualisms—like those between subject and object or between perceiver and thing perceived—no longer apply.

In accordance with this molecular logic, the video for "Catch" effaces the difference between movement by figures in the frame, movement of the camera itself (reframing), and movement effected through fast montage or alternation of frames. Bodies may move, or the camera may move, or motion may be added by means of digital compositing and scanning. But in all these cases, digital processing muddies the conventional distinctions between mise-en-scène (what is captured by the camera), cinematography (what the camera itself does), and montage (what is done afterward with the material recorded by the camera). No matter how these movements are produced, they are all equivalent in the spectator's experience.

The video is almost a compendium of the various ways that images can be looped, alternated, and set into motion. In this way, it exemplifies the *database aesthetic* that Lev Manovich describes as central to digital media (218). There is no linear progression among these visual forms but only a combinatorial display of different configurations. The underlying logic of a database, as Manovich argues, is spatial rather than temporal. The many possible permutations can be presented only one at a time, in succession, but in such a "spatialized narrative," there is no rationale for any one particular order rather than another. The song anticipates a future in which the singer will catch her breath and take her revenge, but for the four minutes of the recording and the video, the singer remains trapped in an ossified present in which none of her incessant reconfigurations can still the agitation or alleviate the pain.

This spatialized visual logic is of course complicated by the way that music is an irreducibly temporal form. The video for "Catch" has no story line, no logic of development, and no conclusion, aside from that provided by the song's lyrics and its verse-chorus structure. But the *rhythm* of the video's visual jerks and twitches is closely related to the relentless beat of the music. While the visual twitching doesn't coordinate precisely with the song's bass line, it does remain closely attuned to it, in a sort of

visual syncopation. For this reason, the video's loops and repetitions do not produce anything like a sense of stable cycles. There is no suggestion of underlying regularity but only a continually throbbing pulse. We might well say, following Gilles Deleuze, that "the unequal in itself" is the only thing that gets repeated, or that returns, in this video (*Difference* 232). Both sonically and visually, the *unevenness* of the beat keeps on coming back and pushing us forward.

Saindon's video exemplifies a new regime of audiovisual images. Time is not just the measure of motion, as is the case in the films of what Deleuze calls the movement-image (*Cinema 1* 152–155). But neither is time unveiled in its pure state, as happens in the films of what Deleuze calls the time-image (Deleuze, *Cinema 2* 9). Rather, we find a different articulation of time and space—and also of sound and vision—than is the case in either of Deleuze's two regimes. Time and space are woven together—and even exchange their roles and characteristics—in the course of the music video's twitchy rhythms. "Catch" jams the sensori-motor circuits of the movement-image, but it also undermines the "pure optical and sound situations" (Deleuze, *Cinema 2* 9) of the time-image. Instead, it drags us into a strange new realm of microperceptions and microaffects, all subordinated to the song's and the video's underlying syncopated pulse.

FKA TWIGS, "PAPI PACIFY"
(TOM BEARD AND FKA TWIGS, 2013)

FKA twigs's song "Papi Pacify" was coproduced by the amazing Arca (Alejandro Ghersi). The music video is codirected by Tom Beard and twigs. The song might be described as a ghostly hybrid of trip hop and R&B. The synthesized music features a lot of rumbling sound in the bass register, together with violent and irregular percussive banging. But "Papi Pacify" is also rather slow in tempo; this makes it feel close to ambient music—with its suspended, floating quality—despite the insistent punctuation of the percussion. Like a lot of recent EDM, the song is devoid of tonal shifts, but it moves between different gradations of intensity, building to a climax through changes in timbre and a thickening of the sound.

In "Papi Pacify," as in most of FKA twigs's music, her voice is heavily processed, so that it resonates like yet another electronic instrument, with its own distinctive timbre. She sings in a high register, which contrasts with the bass-heavy instrumental track. Her voice is also drawn out and amplified, with considerable reverb. There's a breathless, floating intensity to twigs's singing, which moves beyond actual words into drawn-out cries of "mmm" and "ahhh." I cannot avoid hearing twigs's voice as if it were speaking in a near whisper—even

though it stands out, quite loud, at the forefront of the mix.

The emotional tone of the song fluctuates between gentle plaintiveness and outright pleading. The lyrics are deeply ambivalent: twigs begs her lover to "pacify" and "clarify" their love, by assuring her of his faithfulness even if he does not mean it. Empty, lying reassurances are better than none at all. The song is thus about deception and dependency. The singer wills herself to continue trusting her lover, even though she knows that he has already betrayed her. In this way, twigs simultaneously disavows and fuels her own erotic-romantic disquiet.

I cannot really imagine dancing to a song like "Papi Pacify," despite its formal similarities to EDM. For twigs and Arca's music is just too rhythmically irregular and disruptive—not to mention too slow and depressive—to be easily danceable. The off-rhythms convey imbalance and tension, even as the song's overall tempo and its harmonic stasis produce a sense of helplessness and paralysis.

However, dance is central to FKA twigs's art and especially to her music videos. "Papi Pacify" is not literally dance based, in the way that many of twigs's other videos are. But the play of the figures on the screen—the movement of their bodies and even of their hands—is highly rhythmic, suggesting a sort of dance. Even if the gestures and postures in this video are not actually arranged by a

choreographer, they still seem to be "choreographed" via cinematography and editing.

The music video is shot in black and white and composed entirely of images of the faces and upper bodies of FKA twigs and an uncredited male partner. The only bright lighting in the video shines directly on twigs's face and on her elaborately sculpted nails. Though the male partner is never illuminated as brightly as twigs is, we do get to clearly see his face and torso. His sexy, muscular, and athletic bulk stands out against twigs's thin and flexible body. The crisp, gorgeously high-contrast black-and-white cinematography brings out the flesh tones of the two performers. Both twigs and her partner are black; but she is relatively light-skinned, while he is much darker. The video's up-front beautification of black bodies stands in deliberate opposition to the traditional cinema's almost exclusive obsession with pale white skin (and its concomitant myths of white female "purity").

Like many music videos, "Papi Pacify" alternates between two separate series of images. The first series shows twigs engaged erotically with her partner. The second series, in contrast, shows twigs by herself; she wears an ornate necklace and her body is covered with glitter. The first series is confined to medium shots that show us the performers' faces and upper bodies. But the shots in the second series, which appear only in the second half of

the video, vary from extreme close-ups of twigs's eyes to images of her entire face and torso.

However, these two series of images do not correspond, as they often do in music videos, to two separate locations. This is because the video as a whole offers us no sense of location. In both series of images, the human figures emerge from a murky, undifferentiated background. The darkness behind them is too vague and undefined to seem like any sort of actual place. In other words, the video has no settings, whether real or simulated. The actions of the human figures can only be situated within, or on, the electronic screen itself.

This lack of setting means that the video is effectively nondiegetic. We respond to the bodies we see, as to the music we hear, but we cannot take what we see and hear as a represented action (or series of actions) in any particular location. We are rather presented with a mode of *digital and electronic presence* that cannot be translated or resolved into analogue, representational terms. The bodies of twigs and her partner are not absented in favor of their signifying images, as would be the case in a movie (at least according to traditional film theory). Rather, these bodies impinge on the screen and thereby present themselves directly to us, precisely *as* forces and pulsations.

The video is intensely erotic, even though it doesn't show us twigs's breasts or the genitalia of either actor. For

much of the video, the man either has his hands around twigs's neck or else sticks his fingers deep into her mouth and down her throat. At times, twigs almost seems to be on the point of choking. In the YouTube comments to the video, there are fierce arguments as to whether this is a representation of abuse or whether it is rather a positive depiction of consensual BDSM. But as my students pointed out when we discussed it in class, what the video actually shows us is fairly mild, in terms of the actual practices of consensual BDSM.

If the video feels so visceral and intense, this is not just because of the actions that it literally depicts but also because of the extreme intimacy that it expresses. In every shot, twigs is close to the camera. In the shots that include the male partner, he is always positioned just slightly above and behind her; we usually see the two of them with twigs facing the camera. Occasionally the camera is positioned behind the man's back; in these shots, twigs looks toward us only obliquely. In any case, there is almost no physical distance between the two of them; he is always holding her. They also stare into each other's eyes and seem closely attentive to each other's slightest movements and gestures.

But twigs does not just exchange glances with her partner. At other times, though he continues to look at her, she closes her eyes in apparent ecstatic self-abandonment.

And even more frequently, she stares directly at the camera. This means that there is also little sense of distance between twigs and the viewer. She seems to be imploring us or even perhaps exchanging glances with us: in any case, she includes us within the video's flows, its acts of bodily exchange.

Some YouTube commentators say that twigs looks desperate and begging for rescue and that this is why she stares into the camera. But I myself am unable to see it this way. For me, as for many other commentators, twigs's gaze and facial expressions rather imply trust and acceptance. The video is all about intimacy and proximity: between twigs and her partner and also between twigs and us. There isn't enough distance between twigs and the viewer to allow for the objectifying effect of the usual cinematic gaze. Video bodies operate according to a different—and more immediate—logic than film bodies do. We are just *too close* to the lovers to be able to respond voyeuristically to what they do.

Extreme intimacy can of course be suffocating, as much as it can be exciting and fulfilling. The video, like the song itself, expresses both of these at once, in a sort of oxymoronic tension. The music and images alike lack any forward movement toward a conclusion. Things intensify toward the end of the song: the instrumentation gets thicker, while the shots get shorter. Nonetheless, there is

no fundamental change; everything seems to be standing in place. At the same time, however, the sounds and images alike are too tense and off-kilter to suggest any sort of equilibrium or stasis.

The video's presentation of physical contact to the point of suffocation may well go along with what I have called the breathlessness of twigs's singing. It is worth noting, however, that the video mostly avoids lip-syncing. There are some moments when twigs mouths the words—or nonverbal cries—of the song, especially in the second series of image. But more often, she does not do this. Most music videos (except for the ones that directly document or mimic live performance) tend, in varying degrees, to self-consciously call attention to their use of lip-syncing. "Papi Pacify" pushes quite strongly in this direction. The occasional moments of synchronization fix our attention on twigs's face and figure. But because she only lip-syncs occasionally, we are spared both the pretense that she is actually performing the song, or that we are hearing her unmodified voice, and the opposite pretense that the action of the video is somehow "really" happening independently of the song. This is yet another reason why I consider the video to be nondiegetic and nonrepresentational.

All these tendencies are further amplified by the complex editing of the video. Instead of progressive action,

we are given what might be called a series of jump cuts, presenting the same scenes over and over again from a variety of somewhat different angles. The camera sometimes modifies its position very slightly, but otherwise it never moves. A lot of the action—the touching and embracing—seems to take place in slow motion. A few times there is extremely rapid cutting and flashing, which gives an oddly disjointed rhythmic effect in contrast to the overall slowness of the song.

Most strikingly, many of the shots in the video are run in loops, forward and backward a number of times, like an animated GIF. This seems to happen especially when the male partner is pushing his fingers into twigs's mouth and down her throat. This looping repetition results both in a sense of dreamlike slowness and in the impression that these actions are not just done once and for all but rather are repeated over and over. The effect is something like that evoked by the use of the imperfect tense in many languages (though, unfortunately, this form does not really exist in English).

"Papi Pacify" leaves us floating in a strange erotic time, which is not the time of everyday life but also not the "time in its pure state" of Bergsonian duration or of Deleuze's time-image. It is rather an uneven, pulsed time, which ebbs and flows in irregular waves. It's a highly sexualized time. But it is also quite emphatically *not* the

time that leads teleologically to the culmination of male orgasm. We are in a realm of different sexual practices here: one that we might well call "feminine"—but perhaps not, since it is too irregular, too uncertain, and also too intimate to fit easily on either side of the conventional male/female binary. I would like to say, also, that this is a kind of digital and electronic time: one that is not intrinsic to our new technologies in any essentialistic sense but that could not have been accessed without them.

JANELLE MONÁE, "COLD WAR" (WENDY MORGAN, 2010)

Wendy Morgan's video for Janelle Monáe's song "Cold War," from the album *The ArchAndroid*, is a single take with very little camera movement. The singer faces the camera, posed against a dark background. The shot is such an extreme close-up that we can see only (at best) Monáe's head and shoulders and often no more than part of her face, from the chin to just above the eyebrows. Apart from a few minor reframings, the camera remains fixed on her face throughout. Monáe's naked, unadorned look in this video noticeably contrasts with the androgynous drag—wearing a black-and-white tuxedo, hair coiffed in a tall pompadour—in which she most commonly performs. The effect of this look and camera

placement is one of extreme intimacy, because we are so close to the singer and because she looks for the most part directly at the camera and therefore at us.

The camera placement in "Cold War" closely resembles that in John Maybury's music video for Sinead O'Connor's cover of the Prince song "Nothing Compares 2 U" (1990). O'Connor, too, looks directly at the camera, with the same framing. This video, too, is extremely intimate; O'Connor's face is contorted in expressions of distress as she sings of the desolation of losing a lover. Toward the end of the video, two tears roll down her cheeks. If anything, O'Connor's address to us is even more intense than Monáe's, because, as Douglas Wolk puts it, the Irish singer is "wearing a black turtleneck that blends into the background, making it seem like her close-cropped head is all there is in the world."

However, "Nothing Compares 2 U" does not entirely stay with this single extreme close-up. The shot of O'Connor's face is sometimes interrupted, and more often overlaid, by shots of the Parc de Saint-Cloud near Paris. It is winter (the deciduous trees are bare, though there are also evergreens). The singer, dressed in black, walks alone in the park in long shots; sometimes the camera lingers on the park's neoclassical statues and architecture. These shots open up the video a bit; they balance the sheer intensity of O'Connor's face by giving us a some-

what more distanced objective correlative for the sadness expressed in her singing.

"Cold War" does not offer us any such distraction or relief. We never leave the single take of Monáe's face. The only interruption comes at the very beginning. For the first few seconds of the video, Monáe is talking to someone—perhaps the director or the camera operator. But there is no sound, so we do not hear what she says. She takes off her robe at about 0:07, so that she is apparently nude (although we do not see any part of her body below the upper shoulders). After Monáe disrobes, we see a title card informing us that we are watching "Take 1." But then we quickly return to the extreme close-up of Monáe, as the music begins.

This introduction already informs us that there is no direct sound in the video but only the prerecorded song. Lip-syncing is generally the rule in music videos, since the music is recorded first, and the images are only matched to it later. In this way, music videos are the inverse of conventional movies, for which the main task in postproduction is rather to match sounds to preexisting images. Music videos vary greatly in the degree to which they acknowledge and foreground lip-syncing on the one hand or strive to naturalize it on the other. "Cold War" is far on the self-conscious-acknowledgment side of the spectrum. Indeed, in Monáe's extreme close-up, she gives

the impression less of articulating the music we hear than of listening to it along with us and striving to match it with the movement of her lips.

Throughout the video, a time code runs in the lower right corner of the screen. The numbers do not start at zero; rather, they indicate that more than an hour has already been counted before the moment when the video begins. Also, the time code is calibrated down to thousandths of a second—a degree of precision that is well beyond the capacities of human perception. We are thus reminded that the video apparatus operates in a nonhuman way, on time scales both longer and shorter than our own attention spans. Digital cameras, recorders, and screens should be understood as prosthetic extensions of our bodies and minds. All these indications of the video's artifice give the impression that we are not watching a finished product, a completed work of art, so much as we are experiencing a work that is still in process. We seem to be witnessing the operation of raw video capture, as it takes place *before* any work of postprocessing (such as editing and the introduction of digital effects). Of course, this cannot be literally true, but Wendy Morgan does say that what we see in the video "is the complete first take": "This performance is unaltered and unencumbered, as those of us in attendance on that day experienced it" (Fitzmaurice).

This emphasis on the powers of the digital fits well with the way that Monáe presents herself throughout her *Metropolis* suite, of which "Cold War" is a part. Monáe takes on the persona of an android, Cindi Mayweather, seeking freedom in a future science-fictional world. Cindi marks both the extension and the inversion of the figure of the female robot in Fritz Lang's *Metropolis* and many other works. The overall theme of Monáe's suite is the rebellion of the androids, their liberation from servitude to human masters, and their recognition as fully sentient beings in their own right. Most obviously, the figure of the android works for Monáe as a metaphor for the personhood of anyone who is stigmatized as an Other, because he or she does not conform to (white, cisgendered, male-heterosexual) norms. But Monáe also asks us to take the figure of the android literally. Her posthuman Afrofuturist vision mobilizes cutting-edge technologies as vectors of potential transformation (including self-transformation). The technologically enhanced powers of future androids might well extend further than standard human abilities. Android personhood need not remain in thrall to the conventional limits of the human sensorium.

Monáe's music is unusually eclectic in terms of its styles and influences, encompassing everything from hard rock to funk to R&B to Tin Pan Alley ballads. "Cold War" is best described as an up-tempo (160 bpm) alternative-rock

anthem. Its lyrics speak of having the courage to be alone, of sticking to one's values, and of transforming alienation into a source of strength. Monáe sings of resisting the (often internalized) stigma of nonconformity. She insists on asserting her singularity or what might best be called her emotional queerness. Indeed, Monáe refuses to identify herself as either straight or gay, saying instead, "I only date androids"—which is a queer sentiment regardless of gender (Hoard).

In any case, the video is affirmative right from the beginning. For the first minute or so, Monáe looks directly at us as she appears to sing (that is, as she lip-syncs). She faces entirely forward during the verses of the song. Each time she reaches the chorus, she moves her head a bit sideways, but her eyes remain pointed in our direction. The extreme close-up makes Monáe's performance seem hyperreal. My attention is intensely focused on her slightest movements. I get fixated on her eyes and on her mouth. I follow her gaze carefully, and I notice every last articulation of her lips and teeth. Jay David Bolter and Richard Grusin argue that digital media are characterized by "twin logics of immediacy and hypermediacy" (5). This is certainly the case for "Cold War." Watching the video, I am assaulted by the feeling that the singer is just *too close*, too intimately present, without the buffer

of any sort of objective distance. But at the same time, I am equally aware that this closeness is an artifact of the obtrusive presence of the mediating video apparatus. Immediacy and hypermediacy complement rather than contradict each other.

As the video proceeds, a number of odd things happen that disrupt its flow and accentuate this double logic even further. From about 1:14 to 1:18, the image goes blurry, out of focus. Then, at 1:38, during the line "and it hurts my heart," Monáe turns and looks off camera, to her right (our left), and seems to be laughing. The song continues, but her lips no longer match the lyrics. Presumably, she got distracted and blew a line of the lip-sync. She shakes her head briefly and then lip-syncs the song's next line, but then she loses it again, lowering her head and putting her hand up to her eyes. Her head dips below the frame several times; now she looks distressed. During all of this, the camera keeps recording, and the prerecorded music and singing continue. Even when the chorus comes around again, Monáe still seems too distracted to lip-sync more than partially. She recovers a bit, in time to lip-sync a call-out to her guitarist, when he starts his solo at 2:07. During this instrumental break, Monáe nods her head to the music. Since she isn't singing, the camera feels free to pan downward a bit, so that we see more of Monáe's

shoulders and only the bottom portion of her face. The camera shortly moves back up; when the singing resumes at 2:33, Monáe resumes lip-syncing but with a single tear coming out of her right eye and rolling down her cheek—perhaps recalling O'Connor's tears in "Nothing Compares 2 U." The camera briefly loses focus again, from 2:47 to 2:52. For the last minute of the song, Monáe mostly lip-syncs again but also shakes and dips her head. The song ends with the four-times-repeated line "bye bye bye bye, don't you cry when you say goodbye"; Monáe lip-syncs only the final iteration.

These glitches, together with the continually running time code, the lack of sound at the beginning, and the "Take 1" title card, all remind us that we are in fact watching a music video. They prevent us from suspending our disbelief and pretending to ourselves that we are witnessing an actual performance. Wolk, in the best account I have read of "Cold War," therefore suggests that the video uses the Brechtian "distancing effect of calling attention to the apparatus around a performance, to keep an audience aware that it's not seeing something happening in real life. . . . Don't let the tear fool you." But this is only one side of the story; Wolk points up the hypermediacy of the video but ignores its simultaneous immediacy. Other critics have taken the opposite tack; Holly Hargis, for instance, writes that "Monáe uses her tears to break the last barriers

GLITCH AESTHETICS • 75

between herself and the viewers. She is completely vulnerable now and the intimacy is enhanced even more than before."

Evidently, we need to adopt both of these approaches at the same time. The digital medium knows no contradiction between them. Monáe's lip-syncing glitches feel *real* to us, precisely because they rupture the smooth surface of the video performance. Cindi Mayweather is displaced by Janelle Monáe's enactment of Cindi Mayweather. The singer seems overcome by her own song. The emotional intensity of "Cold War" is only heightened by the way that Monáe fails to perform it properly but instead finds herself giving way to laughter, distress, and tears.

3

REMEDIATIONS

Gaspar Noé's video for Animal Collective's song "Apple-sauce" shows us the backlit silhouette of a young woman (the model Lindsey Wixson), in extreme close-up, eating a fat, juicy peach. At the start of the video, Wixson's profile glides into the frame from screen right; then the peach, held in her hand, comes into the frame from screen left. Because of the backlighting, it is only in shadowy outline that we can see her face, the fruit, and her fingers grasping it. Wixson's head is angled about forty-five degrees upward. The camera is so close to her that just a small portion of her profile, from chin to nose, fills the right half of the screen. And when she lifts the peach to her mouth and bites it, nearly the whole left half of the screen is also taken up. Despite the darkness of these backlit figures, we can trace the full contour of Wixson's lips; she is known, after all, for her "bee-stung lips" and "rosebud pout"

(Wikipedia, "Lindsay Wixson"). We watch, in close, sensuous detail, every bite that Wixson takes of the peach and every movement of her mouth as she chews and swallows it. Strands of juicy pulp ooze from the peach; they get splattered all over Wixson's lips and drip from her chin. She licks her lips after her first bite, not letting any of the flavor escape. At end of the video, having finished the peach, she wipes her mouth with her hand.

Behind Wixson, the screen is filled with rapid pulses of color: yellow, blue, red, purple, and other hues, alternating with one another and with white. In effect, these pulsations replace the green (or blue) screen in front of which the scene of Wixson eating the peach was probably shot. Usually, the use of a green screen allows the photographed figures to be composited into a different scene or location; this is one of the most basic operations of digital video. But Noé gives us nothing behind Wixson, except for the screen itself with its pulsating colors. Wixson therefore cannot be placed in any particular (represented or rendered) location whatsoever. Instead, she is a free-floating presence, suspended in the nonplace of sheer electronic transduction. As for the pulsing light, it is no longer just a backdrop for Wixson's figure. For this light is an active element of the video, impinging violently on our perception. The flashing is so rapid that it creates a strobe effect. At the same time that we are

sensuously enthralled by Wixson's mouth and lips as she eats the peach, we are also physically assaulted, almost to the point of shock and seizure, by the continual alterations of color.

All this means that "Applesauce" has an intimate and even tactile feel to it. Watching the video, it is almost as if I can taste and smell the peach and feel the contours of its fuzzy skin and its sticky juice. There is no sense of distance; I cannot take up my usual stance of voyeuristic mastery over what I see. I am just too close to the event of Wixson's eating the peach. At the same time, the pulsing light impinges on, and undermines, any sense I might have of a stable position within the visual field. For both of these reasons, "Applesauce" is a powerfully *haptic* audiovisual work—to use a term that Laura U. Marks picks up from Deleuze and Guattari, who themselves adapted it from the German art historians Aloïs Riegl and Wilhelm Wörringer. A haptic film or video, as Marks defines it, is one in which "the eyes themselves function like organs of touch"; such a work goes beyond sound and vision to present us with a "combination of tactile, kinesthetic, and proprioceptive functions" (2). This is more than just a metaphor; haptic visuality returns us to the *synaesthesia* that arguably lies at the root of our perceptual experience (Ramachandran and Hubbard).

Noé appropriated the video's pulsating background
from *N:O:T:H:I:N:G.*, a 1968 "flicker film" by Paul Shar-
its. *N:O:T:H:I:N:G.* is thirty-six minutes long; it con-
sists mostly of rapidly alternating monochrome frames.
There are also two actual images in the course of the
film: a lightbulb and a chair, both of which appear a num-
ber of times, with alterations. A few short sequences of
N:O:T:H:I:N:G. have sound, but for most of its length,
the movie is silent. Sharits's film has generally been
understood as a powerfully modernist work, a master-
piece of what P. Adams Sitney calls *structural film*: a
form that works only to reflexively present its own actual
structure and functioning (347–370). The chief aim of
N:O:T:H:I:N:G. is to "reduce the process of filmmak-
ing to its most basic components—the projector, the
filmstrip, light and duration" (Dixon). Sharits seeks "to
abandon imitation and illusion"; the film is nonrepresen-
tational, and it aims to "strip away anything . . . standing in
the way of the film being its own reality" (Sharits). All this
fits well into Clement Greenberg's canonical definition of
modernist art as an effort "to determine, through its own
operations and works, the effects exclusive to itself" and
thereby "to eliminate from the specific effects of each art
any and every effect that might conceivably be borrowed
from or by the medium of any other art. . . . Visual art

should confine itself exclusively to what is given in visual experience" (86, 91).

However, there is also another side to *N:O:T:H:I:N:G.*, one that doesn't fit so well into Greenberg's definition of modernist art. When Sharits speaks about his aim to "strip away" all illusionistic elements, he goes on to say that this also means stripping away "anything which would prevent the viewer from entering totally new levels of awareness." Sharits shifts from a reflexive concern with the structural integrity of the work itself to a concentration on manipulating the viewer's experience. From this perspective, *N:O:T:H:I:N:G.* can and should be taken as a mind-blowing, psychedelic work, like so much else from the late 1960s. As one critic circumspectly explains it, the film trades on the possibility that "flickering light could, when viewed under the right circumstances, facilitate a meditative state, similar to that produced by hallucinogens" (Smith 283). *N:O:T:H:I:N:G.* has these psychedelic ambitions because it is an attempt, as Sharits himself puts it, "to deal with the non-understandable, the impossible" and to expose the audience to phenomena "which you are experientially unable to relate to" (Smith 279). Modernism according to Greenberg seeks to attain a Kantian recognition of the limits of all possible experience. But Sharits also pushes toward a dissident, psychedelic strain

of modernism, which seeks to forcibly collapse these limits, even at the price of its own dissolution.

Sharits's two aims—self-referential deconstruction and psychedelic rapture—would seem to be mutually incompatible. The first is anti-illusionistic; the second involves generating intense visual illusions. The first points to the materiality of the apparatus; the second, to the material conditions of embodied perception in the spectator. The first is entirely conceptual; the second, with its paradoxical aim of providing an experience of something that cannot be experienced, is nonconceptual or even anti-conceptual. For it involves what Kant calls "an aesthetic idea, . . . an intuition (of the imagination) for which a concept can never be found adequate" (218). The antinomy between these two approaches is at the heart of Sharits's project.

What changes when Noé appropriates *N:O:T:H:I:N:G.* (or a portion of it) as a background for "Applesauce"? Both Noé and Animal Collective are interested in producing psychedelic effects—though these signify something different in the twenty-first century than they did in 1968 (Hunt). Today, the psychedelic has itself been thoroughly commodified; it is more a stylistic option than a daring transgressive act. Nonetheless, it still has a certain eruptive force. Noé tells us that the video "is

intended to be viewed in complete darkness" (Minsker): this is the way to maximize its sensory, physiological impact. Indeed, "Applesauce" can be compared to Noé's 2009 film *Enter the Void*, with its frequent use of strobe and flash effects and its aim at one point to simulate the effects of the powerful hallucinogen DMT. On the other hand, neither Noé nor Animal Collective seems much interested in the modernist, Greenbergian side of Sharits's project. This has a lot to do with changed cultural circumstances. Twenty-first-century media are utterly promiscuous in their use of modernist formal strategies and effects. But precisely on account of this promiscuity, such aesthetic procedures no longer express any sort of modernist sensibility. Critical reflexivity and medium specificity no longer work as Brechtian alienation effects; instead, they seem only to increase and intensify our sensual absorption.

In the case of "Applesauce," the transfer from film to video undermines the medium specificity that is so central to Greenberg's account of modernism. A flicker film like *N:O:T:H:I:N:G.* requires that a filmstrip be run through a projector. For it works by amplifying the subliminal flicker effect that already exists in the movies, thanks to the repeated, stuttering transition from one film frame to the next during projection. By presenting successive frames in different colors, Sharits points up the way

that the seeming frame-to-frame continuity of the movies is actually an illusion or a construction. But this experience is entirely lost when one watches *N:O:T:H:I:N:G.* streamed as a video file on a computer (which, ironically enough, is the only way that I have been able to view it). Video is a form of electronic, rather than mechanical, reproduction; it has no separate frames. It works instead by continually scanning backward and forward, refreshing one line of the screen at a time. Noé's flickers therefore cannot work in the same way that Sharits's flickers do (though I have not seen any studies that pin down the actual perceptual and physiological differences between the two).

From a high-modernist point of view, "Applesauce" denatures Sharits's movie in at least four ways. First, as I have already said, it displaces the work from film to video, ruining its medium specificity. Second, it synchronizes Sharits's flashing colors to an entirely unrelated, pre-existing sound track. Third, "Applesauce" reintroduces those very illusionistic elements—the human figure against a background, an implicit narrative, a sense of representation—that Sharits strove to eliminate from *N:O:T:H:I:N:G.* And fourth, Noé and Animal Collective have moved the location of the work from the elite spaces of the gallery or the screening room to the wide-open realm of popular culture and to the easy

availability of YouTube. In effect, Noé replaces the critical rigor of modernism with a postmodern aesthetics of opportunistic hedonism.

I do not say any of this as a criticism. If anything, I celebrate the way that cultural production today, with its free-wheeling aesthetic of sampling and remixing and its easy, free availability online, has released us from the straitjacket of modernist rigor and reductionism. This is a pragmatic development, not a process of degradation. Indeed, "Applesauce" is no less divided against itself than *N:O:T:H:I:N:G.* It is only that the terms of the division have changed. Whereas *N:O:T:H:I:N:G.* is split between conceptual and nonconceptual dimensions, "Applesauce" is riven by the conflicting claims of two sorts of intensely embodied aesthetic experience. On the one hand, there is the rich, vibrant sensuality of the woman eating the peach. On the other hand, there is the disruptive shock of the pulsing colors. In traditional aesthetic terms, this is a split between the beautiful and the sublime. On one side, there is the heightened experience of carnal plenitude; on the other side, there is the violence of forces "which you are experientially unable to relate to" but which overwhelm you nonetheless.

The music of Animal Collective on its own already expresses a similar dichotomy. The band's audience, like its membership, consists largely of white Generation X

and Millennial hipsters. Animal Collective's sound is rooted in the tradition of underground, experimental rock, with all its noise and dissonance. But at the same time, its music also pushes toward the melodic sheen of pop (Richardson). "Applesauce" is exemplary in this regard. It is sonically quite dense, but a lilting melodic line soars over all of the chaotic, grinding motion. The song does not follow the traditional verse-chorus structure. Instead, it is composed of six distinct sections. Some of these sections are more chorus-like than others, as they involve backing vocals and close repetitions of melody and lyrics. But this is not a hard-and-fast distinction. This flexibility of structure gives the song a sense of open-ness and extension. All six sections are cycled through twice, and then the song ends with an enigmatic coda. The lyrics of "Applesauce" mention mangoes, apples, and cherries, though not peaches. The song's lyrics draw a contrast between the pleasure of eating ripe, juicy fruit and the disillusion that comes from its going bad. Meta-phorically, the song is about the difference between the sensual enjoyment and seeming plenitude of childhood and the awareness of limits and sense of mortality that come from growing up. Yet despite this ambivalence, the song as a whole has a celebratory feel; its overall mood is lush, visionary, and even ecstatic. The video picks up and amplifies this structure of feeling. Animal Collective and

Gaspar Noé give us an intense rush of sensual pleasure in electronic form, while hinting at the void surrounding it.

KYLIE MINOGUE, "ALL THE LOVERS"
(JOSEPH KAHN, 2010)

What is a pop star? Kylie Minogue is the Goddess of Love. We witness her apotheosis in Joseph Kahn's music video for her song "All the Lovers" (from the 2010 album appropriately titled *Aphrodite*).

The song can best be described as an upbeat, mid-tempo dance anthem. It clocks in at 120 bpm. It has a straightforward structure: verse-chorus-verse-chorus-bridge-chorus. Minogue asks the addressee of the song to dance with her and to accept her love. The verses are pleading, while the chorus is ecstatic and triumphant. The focus of the song is entirely on Minogue herself; we get no sense of her presumptive partner. But there is no doubt that he (if indeed it is a he) will respond to her advances. Despite the intimations of excess in the lyrics, which speak at one point of being (metaphorically) consumed in fire, the mood of the song is relentlessly upbeat. This is a song about sexual pleasure—and not about the extremities of romantic desire pushed to the limit.

The video is set in downtown Los Angeles. During the first verse of the song, the camera mostly stays close to

the ground. In slow-motion close-ups, we see a coffee cup being dropped, a milk container being dropped, a bunch of marshmallows bouncing onto the pavement, and a businessman's briefcase falling open so that the papers inside all fall out. The camera pays special attention to the splattering fluids—hot coffee and cold milk—along the ground. Along with these items, we glimpse a QR code block that supposedly translates to the word "LOVE" (Wikipedia, "All the Lovers"). These shots are cut in with images, often taken by tilting up from ground level, of people pulling off their outer clothes, stripping down to their underwear, and making out with one another. The video then alternates between wide shots of lovers marching down the street, meeting, and passionately embracing and close-ups of kisses, of intimate caresses, and of individual faces in orgasmic ecstasy. The lovers are young people, of all races and genders, and in both hetero- and same-sex combinations. They are all clad in white underwear, picking up the white of the milk and the marshmallows.

We see Minogue herself for the first time when the song moves into its first chorus. The lovers now form a human pyramid; they lift Minogue's prone body above them, as if offering it to the sun. They caress her body even as they hold her up; the ones too far away to reach her wave their arms in sympathy. At the very moment

that Minogue first appears, white doves burst from the crowd, flying upward in all directions. (Remember that white doves were sacred to Aphrodite.) The camera is now high up, so that it either shows us the human pyramid from Minogue's own level or else looks down at her from above. Full-body shots are contrasted with tight close-ups of Minogue's face that emphasize her smile, as well as her lip-syncing. Minogue wears black underwear under a white ripped shirt, and high-heeled boots with a zebra-stripe design and with white kneepads. The video has fairly muted colors, aside from its exuberant display of bright white. Everything is limned by backlighting from the sun, or at least by lens flare.

As the second verse of the song begins, Minogue pulls into an upright position. She waves her arms over the crowd of bodies, in a movement that seems to be both a caress and a benediction. The people lift up Minogue, and she responds by imbuing them with sexual feeling. When the video cuts to a longer shot, we see that the human pyramid has gotten larger and higher than it was before. Shots of Minogue standing out from the mass of bodies are intercut with brief, celebratory visions. White balloons soar upward after being released from a white convertible. The inflatable figure of a white elephant, like one of the big balloons in the Macy's Thanksgiving Day Parade, floats in the sky, wending its way among the skyscrapers.

As the second chorus begins, the camera moves upward following the pyramid of writhing bodies. For the rest of the chorus, the camera either stays with Minogue or gives us longer shots of all the people in the pyramid waving their arms back and forth in unison.

When the song moves into the bridge, the music slows down, and the instrumentation thins out. The video matches this shift with a series of dreamy close-ups of Minogue, once more prone, being gently groped and caressed by all the people surrounding her in the human pyramid. This is the only part of the video that is not brightly lit; the camera is too close to the writhing bodies to show us the sky behind them or to give us the halo of lens flare. In the latter part of the bridge, after Minogue stops singing, the instrumental music picks up again, with a driving, forward thrust. The video cuts to a series of shots at street level, which alternate with shots still focused on the human pyramid. In the street-level shots, a white horse gallops by in extreme slow motion. It passes by a number of human couples who are entirely motionless, caught by the camera in midcaress. It seems as if time itself has come to a standstill.

As the final, uplifting chorus of the song begins, we return to the human pyramid, which is even bigger and taller than before. Minogue once more rises vertically out of the crowd, framed by the daylight sky behind her.

Shots of Minogue singing and of the bodies around her swaying alternate with extreme long shots from way up in the sky. In these shots, we are even above the skyscrapers. The human pyramid is far below; from this distance, it looks like a heap of autumn leaves. The inflatable elephant floats by. As the song ends, Minogue in close-up releases a dove in slow motion, with the sun gleaming behind her shoulder.

The video as a whole is briskly edited, with something like 134 shots in 191 seconds, for an average shot length of 1.42 seconds. There is a definite musical rhythm to the editing; Kahn often gives us very quick flurries of closely related shots (e.g., the human pyramid from various distances), alternating with shots that linger for two or three seconds (e.g., on close-ups of Minogue's face). The camera usually does not move within shots, except when it ascends the pyramid to Minogue on top or when it ascends from her image into the sky. These brief upward movements often just precede or actually coincide with Minogue singing the lyrics "higher, higher, higher."

The video is not simply linear; there are many passages in which it turns back on itself. Nonetheless, there are several general tendencies that stand out in the video as a whole. One is ascending movement. The video begins with the camera mostly on the ground, but it gradually reaches up to the sky. Although the camera sometimes

moves upward, it never moves downward. A second general tendency, closely related to the first, is a passage from particular, intimate details—single individuals tearing off their outer clothes, or isolated pairs of lovers—to the depiction of people in a large mass. Consider the difference between the quick shots in the first verse that show people undressing and the shot at about 1:37, just as the second chorus begins, in which a woman, seen from the back, takes off her shirt and joins the pyramid. The camera does not isolate her and does not show us her face. Instead, it follows her from behind and above as she walks toward the mass of bodes; when she reaches them and sheds her top, the camera continues to move upward, losing the woman and finally reaching Minogue at the apex of the pyramid. Both of these tendencies work to emphasize the glory and beauty of Minogue herself, bestowing love on everyone. Minogue is the only person in the video not paired with another. This is because, as a pop star or as a goddess, she offers erotic bliss to everyone indiscriminately. We can only thank her, worship her, and love her without return.

A third general tendency in the video is its unique color scheme or, better, its overwhelming dazzle of white (leaving aside the tricky question of whether white is actually a color). The lovers' white underwear resonates with Minogue's white shirt and with the whiteness of

the balloons, the doves, and the horse. White is conventionally the color of purity, even aside from its racist connotations. But here, people of all skin colors are wearing the same white. And through a *détournement* of conventional connotations, whiteness comes to signify not virginity or chastity but the exuberant innocence of unhindered sexuality.

In all these ways, "All the Lovers" is a visionary, utopian work. Indeed, Armond White sees the video as a celebration, and idealized reconstruction, of the Stonewall uprising:

> Kylie's diva entreaty rounds up multicultural, ambisexual legions to join her individual ecstasy. It's not a riot, not an orgy, it's an uprising as the swaying lovers amass and their joy takes them literally higher and higher.... Kahn's gleaming fantasy of paradisiacal urban cleanliness is a creative act that idealizes an historical fact.... Rainbow pride expressed as Kylie's bliss.

Minogue herself says that the video "paid 'homage' to her gay audience who helped propel her initial success" (Kearney). The video takes the omnisexual exhilaration of dance clubs in big cities in the 1980s and updates it into the form of a twenty-first-century flash mob (Greenblat). The pop star is a focal point and an amplifier. She takes up

our yearnings and returns them back to us clarified, magnified, and heightened in intensity. Such is the function of celebrity—or better say of divinity—in our contemporary network society.

The video also appropriates, and pays homage to, the work of the American artist Spencer Tunick. Tunick is famous for gathering large groups of people to pose in the nude in striking public locations; he then photographs them. Tunick describes his own work in quintessentially modernist terms. He says that he "stages scenes in which the battle of nature against culture is played out against various backdrops" and that his "body of work explores and expands the social, political and legal issues surrounding art in the public sphere." He also describes what he is doing as "meld[ing] sculpture and performance in a new genre" (Tunick). At the same time, although Tunick has received a lot of media attention, he is largely ignored, or even outright scorned, by art critics and the art world. There's a general sense that, as one critic puts it, Tunick "doesn't seem to have anything to say," so that his extravagant spectacles are "nothing more than upscale advertising" (Fineman). Tunick's work is just too populist to be valued in high-art circles. He is spurned by an art scene in which conceptual sophistication is highly valued, while at the same time high art is more closely entwined with financial speculation than has ever been the case before.

"All the Lovers" entirely avoids these complications. For one thing, the lovers in the video are actively, sexually engaged, rather than just standing there as they do in Tunick's work. For another thing, the economic circuits of music videos are far different from those of video installations. Music videos simply have different affordances, and different potentialities, than works of high art do. Precisely because music videos are "vulgar" and "impure" and necessarily commercially compromised from the get-go, they are not judged in the high-art terms that Tunick unsuccessfully attempts to conform to. The very fact that music videos are always required to serve musical artists and contribute to the construction of their personas means that they are free to experiment in other ways. They often explore the formal innovations made possible by new digital technologies, pushing the limits much as computer games and commercial pornography also do. And music videos can delve into specificities of content without having to justify their proceedings in self-reflexive modernist terms. The deification of Kylie Minogue is only possible under such conditions.

DAWN RICHARD, "CHOICES"
(JAYSON EDWARD CARTER, 2015)

"Choices" is a short song—more precisely, it is character-
ized as an "interlude"—from the 2015 album *Blackheart*
by Dawn Richard, who stylizes her name as DΔWN. The
instrumental backbone of "Choices" is a simple arpeg-
giated chord progression: V–IV–I, with the V sometimes
minor instead of major. This progression is repeated
throughout the song, played by synthesizers and backed
by percussion. DΔWN's vocals float on top of this instru-
mental base. Her singing is fluid and melismatic, drawing
out the song's words. We hear DΔWN's voice clearly,
especially during the first part of the song. But many of
her vocals, especially in the latter parts of the song, are
heavily processed and multitracked, so that they are full of
reverb and sound machinic (if not quite robotic).

The lyrics for "Choices" are quite straightforward, as
they declare the singer's self-love and self-affirmation.
The same words—they may well be called slogans—are
repeated many times in the course of the song. "Choices"
is the next-to-last track on an album filled with emotional
turmoil; it is only after going through a weighty, depress-
ing struggle that DΔWN is able to arrive at a message of
self-empowerment. One critic remarks that the song's lyr-
ics "would sound cringe-worthy coming from pop-peers

[Katy] Perry or [Taylor] Swift, but in Richard's capable hands they're uplifting and inspiring—not eye-roll inducing" (Butterfield). I think that this is indeed the case, for a number of reasons. For one thing, the instrumental propulsion of the track doesn't leave much room for self-indulgence. The words come across as anthemic rather than self-congratulatory. For another thing, the steady, bare-bones structure of the song cuts against the diva tendency of pushing everything to the point of a shattering emotional climax. Indeed, DΔWN's voice works mostly as if it were just another electronic instrument. It shifts and modulates, both when DΔWN indulges in melisma and when she uses Auto-Tune to change her intonation. Nothing could be further from the way that melisma works as an ostentatious display of the singer's virtuosity—as was so often the case in R&B of the 1990s. Most importantly, perhaps, DΔWN is a black woman and an independent artist without affiliation to any major record label. In her case, the struggle for self-empowerment involves risks and difficulties that best-selling white women artists like Perry and Swift never have to face.

The music video for "Choices" is directed by Jayson Edward Carter, who is best known as a still photographer and gallery installation artist. He makes altered photographs and animated GIFs much more than he does videos. DΔWN makes most of her videos in collaboration

with the director Monty Marsh, but "Choices" is not the only case in which she has reached out instead to other sorts of visual artists. Her science-fiction-robot video for "Calypso" is directed by the GIF artist Kytten Janae, and her "fashion film" video for "Wake Up" is directed by the fashion still photographer Sasha Samsonova. DΔWN has also made futuristic-looking videos with the help of digital production studios, such as We Were Monkeys ("Tide: The Paradox Effect"), Prefix Studios ("Not Above That," lyrics video), and VR Playhouse ("Not Above That," 360-degree VR video). I presume that DΔWN enlists these collaborators after finding their work online. In any case, DΔWN has long maintained that her music also has a visual aspect: "I see everything in body shapes, everything visual. . . . It's so important to make that marriage between music and the body" (Syme). Dance and visual design are not just background elements for her; they are essential dimensions of her work.

Jayson Edward Carter, for his part, describes his own work as postphotographic: "'Multi-process photo art' describes my practice without all the existential weight of the word 'photography.' The majority of the works begin as photographs, but are put through both digital and analog processes in an effort to totally transform the image. If unedited, untouched photographs are 'real,' consider my works intentional perversions of reality" ("About").

In other words, Carter's work is transformative rather than representational. It does not depict or reflect a pre-existing reality; instead, it actively changes that reality, by denaturing and perverting it. Carter locates the truth of images in the actual processes by which they grow and change, rather than in their supposed, static resemblance to the objects to which they initially refer. This is why he regards "unedited, untouched photographs" as "real" only in quotation marks. When Carter refuses to accept the photograph as a given but instead goes on to alter its images in ways that he describes as "perversions," this means that his own work continues—or, better, it *détourns*—the very processes that give rise to images in the first place. Elsewhere, Carter describes his work as an attempt "to incorporate deliberate distortions, alluding to the infinite permutations of what a body can be" (Carter, Flickr page). His art actively proposes ways that human bodies *could be different* than they usually are. In this way, he hopes "to refute those exclusive, often unattainable conventions" that subordinate human bodies to the norms of whiteness and heterosexuality (Carter, Flickr page).

The video for "Choices" processes and transforms DΔWN's image in various ways, just as the musical production of the song transforms her voice. We do not see DΔWN's body in any defined physical space but only

as a silhouette or even as a screen. DΔWN becomes a vital surface, on which text and abstract patterns are inscribed—or, better, projected. The video is mostly in black and white. The first shot shows us what seems to be the upper half of DΔWN's body, lit up against a background of total darkness. But the image is blurry and out of focus, and alternating bands of white and black run down its length. The second shot, coinciding with the second run-through of the arpeggiated chords, shows us an in-focus, extreme close-up of DΔWN's face, specifically her nose and her left eye. The black and white bands continue, like shadows, to run across her face and down to the bottom of the screen. The third shot is just a title card: the word "CHOICES" appears in white letters against a black background. At 0:12, this printed word is broken up by interference, as if the video's scan lines had become misaligned. More interference—in the form of horizontal patterns of yellow, blue, and green—runs up the length of the screen for less than a second.

At 0:13, the video reverts to black and white. DΔWN starts singing at 0:16. In the course of the video, we see a number of different black-and-white image patterns running across the screen. One series of images involves alternating black and white stripes sliding up and down over DΔWN's face. The stripes get curved when they encounter her nose. Occasionally we can discern one of her eyes,

staring out from beneath the stripes. Though this series of images is usually in black and white, it suddenly turns into color at the very end of the video, from 2:21 to 2:31. DΔWN's face is bathed in white, with blue outlines; the stripes are red, yellow, and very dark shades of purple.

Another repeated image series features psychedelic swirls running counterclockwise over DΔWN's face and body in profile and simultaneously clockwise in the space around her. DΔWN seems to be nude; her long, braided hair hangs far down her back, and her arms are folded over her breasts, as flows of energy seem to run through her body. Yet another series overlays two images of DΔWN's face, flashing alternately on and off. One face image looks straight toward the camera; the other is a profile, facing right. All these images give us DΔWN's body as an energy field or a site of active transformations, rather than as a passive object of our gaze.

In much of "Choices," as in one strand of Carter's photographic work, electronically produced text is projected over images of bodies. Usually this text consists of short phrases or slogans. In this way, the words themselves function as graphic elements on the screen; just like other images, they are fragmented, repeated, recombined, and subject to other sorts of patterning. For instance, we frequently see words from the song's lyrics—"I CHOOSE ME"—scrolling either up and down or continually upward

over the outline of DΔWN's body. From 0:30 to 0:34, we see another phrase from the song, "I LOVE ME MORE," repeated numerous times, gently waving up and down, in front of DΔWN's motionless, and heavily tattooed, back. At another point, lines of text, alternately reading "LOVE" and "HATE," waver back and forth in opposed directions. At still another, lines of text blink back and forth, alternately reading "YES" and "NO." From 1:28 to 1:31, the repeated word "CHOICES" scrolls vertically, one letter at a time, down the center of the screen. At the very end, the words "I CHOOSE ME" appear in white over a black screen, like a title card, just as the actual song title did near the start. But here there is no interference, and the words persist after the song is over.

At one point, the video also references the Black Lives Matter movement, formed in protest against the murders of black people by the police. Starting at 0:51, the image of a gun blinks on and off several times, either against a black screen or superimposed over DΔWN's nude back. Then there is an x-ray image of a human torso, especially the lungs. A second x-ray image is superimposed: two skeletal hands moving over the lungs. Beneath this image, the video spells out the phrase "I CAN'T BREATHE"; these were the last words of Eric Garner as he was being choked to death by police officers on July 17, 2014. All this helps to remind us that the wider context of DΔWN's

self-affirmation is the continuing oppression of black people in America.

DΔWN is an Afrofuturist artist, and "Choices" is one of the videos that express this. Afrofuturism—as described by Kodwo Eshun and Ytasha Womack, among others—involves the use of science-fictional tropes and narratives in order to both express and transform the condition of black people, especially in the diaspora. Afrofuturism seeks to break free from the racism and oppression of the present moment by looking both to the past and to the future. On the one hand, Afrofuturism seeks to rescue lost histories from oblivion; on the other hand, it imagines a future of emancipation and self-transformation, enabled by new, advanced technologies. Think of how Sun Ra and Parliament/Funkadelic look back to the pyramids of ancient Egypt and at the same time look forward to spaceships. Today, the best-known expression of Afrofuturism is probably Janelle Monáe's epic narrative in which she is a cyborg in a futuristic world, escaping from slavery.

DΔWN explicitly uses science-fiction elements in some of her videos, most notably "Calypso," in which she is transformed into a posthuman cyborg, and all three versions of "Not Above That," which emphasize sleek, futuristic design, high-tech body alterations, and space flight. But DΔWN is also Afrofuturist in a more general sense, with her wholesale embrace of new digital technol-

ogies, both sonic and visual. "Choices" depends musically on DΔWN's computer-assisted modulation of her voice and visually on the way that her body image becomes a platform both for patterned abstractions and for electronic sloganeering. It is only through these technological transformations—of voice, body, and mind all at once— that she is able to imagine *choosing herself* in a world where black women have mostly been denied even a modicum of choice.

4

LIMITS

It's night. A man is standing far from the camera, in the middle of an otherwise deserted alleyway. It is fairly dark. There is a single streetlight in the middle distance, way up high, a point of light illuminating the fronds of a palm tree. In the far distance, well behind the man, there's a street with occasional traffic and additional lighting. The camera moves up the alley, slowly approaching the man; we hear dogs barking in the distance. At about 0:15, these street noises cut out, and the screen goes black for several seconds. Then the music starts.

This is Hiro Murai's video for Massive Attack's song "Take It There," from its *Ritual Spirit* EP (2015). The song is melancholy and down tempo, though not as slow as many other Massive Attack tracks. It clocks in at 126 bpm, which is not atypical for pop songs. But unlike most pop songs, here the sound remains largely in the bass register, with drums and low piano notes beating out a waltz meter

(3/4 time). In this music, as one critic puts it, "textures and atmospheres" count for more than melody (Duffus). For the song's two verses, the band's leader, Robert "3D" Del Naja, and the former Massive Attack associate Tricky trade obscure lyrics against this minimal orchestration. Their voices seem to hover in between speaking (rapping) and singing. It is only in the choruses that the melody opens up and the sound becomes thicker, with guitar and backing vocals. These voices promise or warn us that we will lose our minds. The song is four and a half minutes long, but the vocals cease at about 2:35. The rest of the song is exclusively instrumental. It reprises the melody from the chorus, several times, with thicker instrumentation at each iteration. In the last twenty seconds of the song, we return to the initial motif of just piano and drums.

The musicians do not appear in the video. Instead, the man we saw at the beginning (played by the actor John Hawkes, best known for his roles in the TV series *Deadwood* and the movie *Winter's Bone*) stumbles about, at night, in a desolate urban landscape. During the first verse of the song, he passes by a wire fence and into an empty field. Sometimes we see his shadow on the ground or views of wet pavement after a rain. During the second verse, the man lurches down a city street. In one shot, a public phone hangs desolately off the hook. The only

brightly lit sequence in the video comes from 1:45 to 2:00, when Hawkes walks by a courtyard/entryway to a small building. The walls are covered with vivid, colorful murals, depicting bulls, pigs, and other animals in grotesque postures. An older, balding man sits at a yellow table, looking enigmatically at Hawkes as he passes by. You can't quite say that there is an eye-line match between the shots of Hawkes and those of the older man, but it is the closest the video comes to depicting any sort of human contact.

Hawkes is dressed in a brown trench coat over a white buttoned shirt and dark pants. His face looks utterly ravaged; it registers nothing but pain and fatigue. The man may well be drunk or sick, and he is unquestionably exhausted. He can barely stand up and seems incapable of walking in a straight line. He pulls himself along in an unsteady shuffle; he falls to the ground several times and holds himself up at other times only by clinging to a fence or a lamppost. He has a lit cigarette in his hand, and he manages to take a puff occasionally.

The video follows Hawkes's steps closely with a moving handheld camera. Especially in the first half of the video, this camera is unsteady and erratic. It mostly shows us bits and fragments, like a view of the man's feet splayed out in all directions as he pulls himself along or an angled shot that shows only the back of his shoulder or a close-up

of his hand clinging to the mesh of the fence for support. There are a few shots that are fully focused and a few that show things at a distance. But most of the shots in the video's first half are fuzzy and out of focus, with city lights reduced to background blurs. The man played by Hawkes is just on the verge of collapse, and the camera echoes his condition with its fragmentation, its blur, its skewed angles, and its lurching movements.

Despite all this, "Take It There" is actually a dance video. Four female dancers join Hawkes, first during the song's two choruses and then during the extended instrumental reprise of the chorus that makes up the second half of the song. Our initial intimation of these dancers comes when we see four shadows projected on the ground, toward the end of the song's first verse. Then, as the chorus begins, the women walk in from outside the frame and surround Hawkes in a large, otherwise empty field. They are all dark-haired and all identically dressed in long black coats, with dark, loosely fitting pants and sturdy boots. They dance around the man in such a way that their coordinated steps and fluid motions are somehow in sync with his troubled gait. For instance, when he stumbles and falls, they all swoop down to the ground in a crouch.

When the chorus ends, the dancers disappear. Hawkes suddenly finds himself once more alone, in a long shot

showing the same empty field as before. He is alone for the entire second verse, aside from his not-quite-contact with the older man. Toward the very end of the verse, for a second we again see a shot of multiple shadows on the ground, presumably those of the dancers. We then move into the song's second chorus, which is bracketed by shots of a tram whizzing by, just in front of Hawkes; it moves diagonally across the screen from back left to front right. After the first passing of the tram, the dancers suddenly step out from the shadows behind Hawkes, almost as if they were emerging from his silhouette. This time, he stands still, only swaying slightly, as they revolve around him. The dancers' movements are fluid and graceful, and yet the way that they alternately raise their arms and kick out with their legs somehow resonates with Hawkes's debility. This is partly because of the skillful editing, which continues to juxtapose close-in shots with long shots, and well-focused shots with ones that reduce everything to a blur.

The dancing is choreographed by Ryan Heffington, whose many video credits include an earlier video for Murai (Chet Faker's "Gold," 2014, with three young women dancing in the dark on roller skates) and a number of Sia's recent dance videos (most notably "Chandelier," together with others featuring the child dancer Maddie Ziegler). In "Take It There," as in other videos Heffington

has choreographed, he bridges the gap between the patterned movements of abstract dance and familiar everyday gestures. The four dark dancers seem to be extrusions of Hawkes's extreme exhaustion, as if their fluid gestures had somehow been stylized from his ungainly stumbles. At the same time, the dancers also seem to personify occult forces; some reviews have even characterized them as "demonic." I am inclined to think, however, that the dancers do not drive Hawkes's character to destruction so much as they are there to make sure that he does not actually die. Death would put an end to his suffering. But instead, the dark figures force him to keep on moving, without respite, despite his utter exhaustion. It is almost as if the dancers embodied the famous Samuel Beckett line, "you can't go on, I must go on, I'll go on" (407).

There is a major shift in the second half of the video, corresponding to the end of the vocals and the instrumental-only portion of the song. At the conclusion of the second chorus, a tram once more passes by; Hawkes totters and then falls down just alongside the tracks at 2:41. A quick edit, with a careful match on action, shows him hitting the ground, at 2:42, in an entirely different setting. The second shot is also askew at a sharp angle. But Hawkes's body has the same mass, and the same screen location, across the two shots. This creates a strong feeling of continuity, despite not only the change

in framing from straight-on to canted but also the fact that Hawkes is starting to tumble toward screen right in the first shot, while in the second, he hits the ground with his head toward screen left. The camera then quickly rotates even more askew, before cutting to a long shot that is straightforwardly horizontal.

The long shot shows us that Hawkes now lies prone on the bottom of an empty swimming pool. In the back, there is a fence; beyond it, there are houses. The lighting from the houses and from street lamps makes for stronger illumination than in the first half of the video, although it is still night. The dry swimming pool remains the sole setting for the rest of the video. Also, from this point onward, the shots are nearly always in focus. And the editing, mixing longer shots and close-ups and keeping the camera on the same side of the pool (i.e., observing the 180-degree rule), is far more conventional than in the first half of the video.

After a few seconds, Hawkes rouses himself, turns around, and manages to stand up again. The women dancers once more appear behind him, starting at 2:59. This time, Hawkes coordinates his movements with those of the dancers; he raises his arms in the air whenever they do. At about 3:27, the dancers cluster around Hawkes and hold him up. They move his arms, legs, and body around as if he were a puppet; they even give him a drag on his

cigarette. At about 3:40, the dancers open their mouths wide as if they were vampires just about to devour him; his mouth opens wide too, matching the dancers in an unheard scream. A few seconds later, he starts to join in the dance with greater enthusiasm; close-ups at 3:52 and at 4:02 show him smiling with enjoyment and even perhaps ecstasy. It is almost as if he has been rejuvenated, just for a moment. Perhaps it is just that the horror of total exhaustion has somehow been captured, honed to a point, and aestheticized—in the music, in the dancing, and in the video as a whole.

For the last twenty seconds of the song, with the return of the initial minimal motif on piano and drums, the dancers let go of Hawkes and walk away from him, exiting the frame. He is alone once again. He stumbles a bit and then falls to the ground in the same posture as when he first appeared in the empty swimming pool. The camera pans up his body, toward the head. Then the video cuts to an extreme close-up of Hawkes's face, just as the song fades away with one final reverberation. The shot holds for a few more seconds in silence; then the screen goes black. Even in this final shot, however, Hawkes's character is not quite finished. He is still breathing, and his eyes still move about, as if to scan the environment. The terminal stage of fatigue is neither death nor the loss of awareness but rather the continuing inability to *not* feel.

Some critics (e.g., Duffus) have compared the "Take It There" video to Michael Jackson's "Thriller" (1983, dir. John Landis; choreog. Michael Peters with Jackson). Of course, "Thriller" is the most famous music video of all time, and nothing since can escape its influence. Nonetheless, this particular comparison seems dubious to me. For one thing, the style of dancing is quite different between the two videos. For another, whereas "Thriller" is spectacular, Murai's video minimizes spectacle. For yet another, the dancers in "Take It There" are never defined explicitly as monsters, in the way that the ghouls and zombies are in "Thriller." Heffington's understated choreography, exploring the proximity between abstract movement and everyday gestures, has little in common with Jackson's splendidly exuberant dancing. And "Thriller" is all about Jackson's magical powers of self-transformation, whereas "Take It There" is rather about the main character's inability to transform himself or escape his condition—even if he seems to come close for a few seconds.

The time of the song and the video—the time of fatigue—is alien and yet inescapable. It is hard to represent the experience of extreme fatigue in sonic and visual terms, because that experience is precisely one that undoes our ability to grasp and comprehend any such representations. But one of the crucial powers of *twenty-first-century media*, as Mark Hansen calls them, is

the way that these media make it possible for us to access, indirectly, those mental processes that "occur at time frames well below the thresholds constitutive of human perceptual experience" (4). From this point of view, "Take It There," with its powerful combination of everyday and formalized gestures of tiredness, manages to express the condition of fatigue. We are led to experience, at least vicariously, the paradoxical state of being unable to access and hold on to our own experience. The video manages this through Heffington's careful attention to bodily expressions, Murai's understatedly elliptical cinematic style, and Massive Attack's seductively melancholic rhythms.

SKY FERREIRA, "NIGHT TIME, MY TIME" (GRANT SINGER, 2013)

Sky Ferreira's song "Night Time, My Time" unfolds in a blurry, druggy haze. It's slow and gloomy, in a minor key, with two short verses and choruses followed by an extended outro. The song is dominated by a harsh guitar drone, reminiscent of the early Velvet Underground. The drone plays for three and a half minutes over a skeletal, off-kilter drumbeat. Ferreria sings in a low register, with a voice that is fairly husky and yet not far from a mumble. During the choruses and the outro, her voice in multitracked and processed with high reverb. The combination

of muffled voice and insistent drone is what really drives the song. The lyrics are brief, chilly, and despairing. They are mostly taken from the dialogue of the doomed, sexually abused Laura Palmer (Sheryl Lee) in David Lynch's film *Twin Peaks: Fire Walk with Me* (1992). In the outro, Ferreira continually repeats the words "faster and faster"; the drone thickens and becomes ever more dissonant. Eventually, it drowns out Ferreira's voice altogether. The song ends abruptly, rather than fading away.

Grant Singer's visualization of "Night Time, My Time" follows the strategy, common in music videos, of cutting back and forth among a number of sequences, each of which provides a different image of the singer. Ferreira appears in every shot; there are no other people in the video (with the possible exception of the back of somebody's head, which we see at the bottom of the frame at 0:55). But she has a different look—different clothes, different wigs, different makeup—for each group of shots. In her performances and videos, Ferreira usually appears as a blonde, but here her long hair is either dark or a garish red. Some of the time she lip-syncs, but more often she does not. The lip-syncing itself is fairly casual, imprecise, and discontinuous; no effort is made to convey the illusion that Ferreira is really singing live. The video is quite dark for the most part, as befits a song about the night. It has a muted color palette. All the exterior shots are

taken at dusk or at night. The interior shots are set in a number of windowless motel rooms, with indirect lighting. The rooms seem to be theme rooms, with distinctive decorative features. For instance, one room is tinted red and uses an automobile chassis as a bed frame. Another is tinted blue, with a huge monochrome painting of what seem to be trees in the forest on the wall behind the bed. According to the director, the video's footage was shot all in a single night, at an actual motel in the desert outside Los Angeles (Singer).

In one series of shots, Ferreira walks down an outdoor corridor, past a row of motel rooms. She wears a white fleece wrap over lingerie and high heels, and her hair is black. At first, we see her only from behind, walking away from the camera; later, we see her from the front, walking toward the receding camera. Her dark hair covers most of her face. She looks backward, over her shoulder, in hesitation or worry. Is she supposed to be a hooker, uneasy about her clients? In a second series of shots, Ferreira rides a big hobbyhorse, facing toward screen left, and rocking back and forth perpendicular to our line of sight. She wears a baby-doll dress with knee-length stockings and buckled shoes. At first, we only see details: the head of the hobbyhorse or Ferreira's leg in the stirrup. Each time we return, we get to see more of her body. Behind Ferreira, on the back wall of this motel room, there is a

large disk, glowing bright yellow like an artificial moon. These shots are significantly brighter than anything else in the video. In a third series of shots, Ferreira is dressed only in lingerie and with her hair an unnatural red. She writhes around on a motel bed with red sheets and purple pillows; at 1:59 and again at 2:17, she seems to be masturbating. In still another series of shots, Ferreira sits or lies on the bed in the bluish motel room. She has black hair and bright red lipstick; she is wearing a striped white blouse. At first, she is wearing sunglasses as well, but she takes these off at 1:02. At times, she seems to be performing a mock strip-tease for the camera; at 2:56 or so and again at 3:08, she seems to be dry heaving on the bed.

There are also several series of outdoor shots involving an automobile. In all of these, Ferreira's long hair is a violent red-orange. Sometimes she is a passenger in the backseat of a moving car; she lip-syncs, or her forehead rests against the side window. In another series of shots, she dances in front of the car, in high heels, wearing the white fleece wrap over lingerie. She pretends to be walking on a tightrope, with arms outspread for balance and one foot placed carefully in front of the other. The car's headlights are on. These are the only shots in which it still seems to be dusk; the immediate surroundings are already dark, but a glow still lingers at the top of the screen, on the far horizon. Later, there are otherwise similar shots

in full darkness; Ferreira alone is illuminated, presumably by an off-screen (and nondiegetic) spotlight. In the far distance, we see out-of-focus streetlights. There is also another series of outdoor nighttime shots, in which Ferreira sits on the hood of the car. Sometimes she pulls her wrap around her; at other times, she lets it drop and huddles with her arms folded across her breasts, wearing only lingerie.

"Night Time, My Time" also has a mysterious series of extremely brief shots in which we see Ferreira's face in extreme close-up, with water droplets over her face, as if she had just doused herself in the sink or the shower. The first of these, at 0:13, shows her face upside down; it's a red monochrome, light coming from the left, and the right half of her face (from our point of view) in shadow. The next shot in this series comes at 2:10; this one is tinted blue. We mostly see Ferreira's black hair; she seems to be lifting her face from what may be a sink. At 2:43, this lifting motion continues, until she is looking at us with mouth agape. At 3:14, her damp face is positioned sideways and lit from above, with another hint of blue in the background. There's yet another extreme close-up at 3:21, with blue and purple background; her head is lifting up, though we mostly just see her hair; there are bars between her and the camera, which also ascends. This arrangement is repeated at 3:26, except with reddish background

lighting instead of blue. Finally, the last shot of the video (after a brief black screen) shows Ferreira's wet head again, in blue monochrome; light comes from the right, so this time the left half of her face (from our point of view) is in shadow.

The shots in this series flash by so rapidly that they are nearly subliminal in their impact, but they seem to me to be important inflection points for the video. It's almost as if these nude shots marked a hidden, basic reality, or a ground zero, that is covered over by all the other series of shots. Also, the final shot of the video partly matches the shot of Ferreira (photographed by the film director Gaspar Noé) on the cover of the album to which this song gives its name. The album cover shows Ferreira in the shower, with water droplets on the shower door as well as on her body. The image is tinted green, rather than blue; it is evenly lit, and it extends down further so that we see her breasts as well as her face.

There is no way to give a straightforward "reading" of all these images and personas. Ferreira is clearly sexualized by her presence in front of the camera. But it is more ac-curate to put this in terms of her own self-representational agency: she is consciously posing, and playing with, images of her own sexuality. Her postures and clothes often suggest the femme fatale of film noir. But these looks are not consistent; Ferreira's facial expressions run

the gamut from aggression and self-assurance to suggestions of vulnerability and victimization. Ferreira never smiles in the course of the video. Her glances are confrontational and contemptuous, the few times when she acknowledges the presence of the camera at all. Overall, the video feels claustrophobically self-contained; it implodes or short-circuits, rather than reaching outward. Whether Ferreira is masturbating or retching, or anything in between, her actions all redound back on herself. She does not offer up her image to a dominating male gaze, as women in film noir so often did. Rather, she denies the viewer any sense of spectacle or exhibitionistic display.

The music of "Night Time, My Time" is fairly slow (110 bpm), but Grant Singer's editing is fast. By my count, there are 131 shots in 216 seconds, which gives an average shot length (asl) of about 1.64 seconds. It's worth reflecting on this for a moment. Such a shot length is significantly shorter than the average shot lengths of most feature films and even of action movies that are said to display "MTV-style editing" (Hollywood Lexicon). For instance, a beautifully and classically edited action film like *Mad Max Fury Road* (George Miller, 2015) has an average shot length of 2.6 seconds. The aggressively fragmented editing style of Michael Bay's *Transformers* series (2007–) clocks in at an average shot length of 3.0 seconds or higher. Even Tony Scott's *Domino* (2005), which continually uses jump cuts

as a substitute for reframing, has an average shot length of 1.72 seconds, slightly higher than that of "Night Time, My Time" (Cinemetrics).

This contrast between music videos and action films is not surprising. Movies displaying what David Bordwell calls "intensified continuity" or what Matthias Stork calls "chaos cinema" or even what I have called *post-continuity* still endeavor to present some semblance of linear narrative. This obliges them to delineate relative positions in space and time—however inconsistently they do so and however much they depart from classical editing norms. But music videos are free from any such obligations in the first place. Even the ones that do tell stories tend not to be very concerned with movie-style continuity editing. Already in the early 1990s, Michel Chion noted that the music video "does not involve dramatic time," so that it cannot be judged in terms of "cinematic criteria that apply to linear narrative" (166). At around the same time, Andrew Goodwin warned against emphasizing "the discontinuous visual structure of music video," at the expense of ignoring the continuities and structures that are provided by the preexisting songs (3).

Although the average shot length for "Night Time, My Time" is quite short, Singer's editing does not subjectively *feel* particularly fast. It accommodates itself to the slowness of the music and to the continuity provided by the

drone. The many images of Sky Ferreira resonate with one another across the multiple series. At the start of the song—during the instrumental introduction and then the first sung verse—we mostly see Ferreira only in fragments: just her legs or just her face or just the blouse covering her midriff. As the first chorus begins, at 0:44–0:47, the camera offers us a kind of punctuation, by showing the sky at dusk and then panning down to the first full-body shot of Ferreira dancing in front of the car. From this point on, frontal shots become more important. In the last minute of the video, during the outro, as Ferreira sings the words "faster and faster," the editing speeds up; there are more rapid cuts among the various image series, and the camera often sways a bit, creating a sense of vertigo.

Despite the brevity of the average shot length, nearly every shot in the video features a moving camera. Often, when Ferreira is in the center of the screen, the camera moves either toward or away from her. At other times, the camera moves laterally. Within this general context, Singer often creates slightly odd and disquieting effects. For instance, at 0:53, the camera catches Ferreira in the bluish room from the side instead of from in front. There are also obstructions—most likely bedposts—between her and the camera. Starting from this shot, the camera pans to the left, until Ferreira is out of frame, and all we can see is a blurry pattern of blue and black. But at this point, before

we can discern any rationale for the camera's motion, there is a quick cut to another shot, from the series that shows Ferreira lip-syncing in the car. She is on the right side of the frame. The pan to the left, followed by a cut to an image on the right, sets up a visual rhythm, even though we cannot give this pattern any intelligible meaning.

In addition to these sorts of contrasts, Singer also employs a number of familiar continuity editing techniques: matches on action, graphic matches, cutting between establishing shots and close-ups, and even eye-line matches. However, in contrast to traditional continuity editing, these links between shots do not establish spatial continuity and uniformity. At about 1:49, for instance, there is a cut from (1) Ferreira with black hair mostly covering her face, in the left half of the screen facing more or less to the right, to (2) Ferreira with red hair and fleece wrap, in the right half of the frame looking left. Both shots are extreme close-ups of Ferreira's face, and in both, she is lip-syncing. This creates a strong formal connection between the two shots, even though they are set in two separate locations, with two different iterations of Ferreira. The psychological associations behind continuity editing are still at work, but they are no longer attached to any supposed delineation of space.

There are many such micropatterns in the video; they link together disparate images, we might say, without

unifying them. Of course, an underlying unity is provided by the continuity of the music, as well as by the totality of Sky Ferreira's celebrity image. But Ferreira is refracted into a multitude of particular realizations, scattered across both space and time. These images are continually juxtaposed and mirrored, in multiple fractal configurations, without their differences being effaced. Of course, most of these patterned contrasts have a largely subliminal effect, since the only way to notice them consciously is to play the video over and over again, stopping it every couple of seconds (as I have done). But even without such careful scrutiny, the video expresses a powerful sense of anomie and melancholic desperation. Singer's cinematography and editing do not work to establish space-time relations in the way that such techniques do in narrative movies. Instead, they push on, to the very limits of microperception, beyond anything that can be discerned by the unaided eye.

KARI FAUX, "FANTASY" (CARLOS LÓPEZ ESTRADA, 2016)

Kari Faux's "Fantasy" is a bleak little song about breakups and depression. The music is fairly minimal. All we hear at first is a repeated bass line. After a moment, Faux starts to rap above the bass. At first, the only percussion is a quick snap on the offbeat. Gradually other instruments join in,

and the music becomes a bit less sparse. We hear drums, piano, sax, and synthesizer; they mostly provide ornamental jazz riffs. The song has three verses; each time the instrumentation is a bit more fleshed out. In these three sections, the usual verse-chorus structure is inverted. The chorus with its bass-line hook comes first; the verses proper follow. In the third verse, there are vocals only during the chorus; in place of a third set of lyrics, there is only an extended instrumental coda. The dropout of the voice, together with the music's overall slowness—it clocks in at only 85 bpm—makes the song feel entropic, as if it were winding down to a final stasis.

"Fantasy" is an anti–love song. Faux's voice is nearly monotone; it suggests an endless weariness. The opening refrain starts out with what could be construed as a feminist statement. She tells the "you" to whom she addresses the song that she will not conform herself to any fantasies he might have as to what she is like or to how he expects her to behave. But in the next few lines, Faux turns from self-affirmation to something that is more like self-reproach. Now she complains that she hasn't had the "chance" to be anyone's fantasy. She slips from proudly refusing to make herself into a man's plaything to lamenting her lack of opportunity to do so. Finally she just throws over the whole thing and announces that she has simply "given up."

The verses expand on this declaration, telling us that love is "temporary" and meaningless and that it leads only to disappointment. In the first verse, Faux tells a lover that she knows he will "soon be gone"; she recommends just "living in the moment," since there is no future anyway. In the second verse, she warns a prospective lover that she isn't worth it; she will only disappoint him or torment him. This all makes for a classic no-win situation. Faux cannot sustain a relationship, because she cannot turn herself into the object that a man desires. Either the prospect of becoming somebody else's fantasy disgusts her too much, or else she is simply incapable of submerging herself in this way. Most likely, she feels a combination of both. But Faux also knows that, even if she were capable of transforming herself into a man's fantasy object and entering into a relationship on this basis, doing so would not give her any satisfaction. This is perhaps why the song has no third verse but only an ominous, downbeat instrumental coda; Faux has exhausted the subject, and there is nothing more to say.

Carlos López Estrada's music video for "Fantasy" is both melancholic and absurdist. The cinematography closely follows the structure of the song. It features three slow, steady 360-degree clockwise pans, circling around in a single space. These correspond to the song's three verses. At the start of the video, before the song begins, we hear

traffic noise as the camera slowly zooms toward an apartment building of something like twenty stories. It's night. There is a cut to a medium close-up of a small, old-style black-and-white television set: it has a CRT and a screen with the old 4:3 aspect radio. The video itself is shot in this anachronistic ratio, in contrast to nearly all videos today. The TV set stands on a table; there's a remote to the left of it and a toy robot to the right. The TV buzzes with static for a few seconds. Then it clicks on and presents the image of a man with a double bass. He starts playing the opening riff of the song.

Once the music starts, the camera pans to the right. It quickly leaves the TV set behind. We seem to be in a small apartment. The camera moves over a portion of wall with a door and a wall phone. It reaches a dining area just as Faux begins to rap. She is seated at the dinner table wearing a black bra, with a colorful blanket or wrap pulled loosely over her shoulders. She sits there calmly, lip-syncing the chorus as she stirs a cup of coffee. The table is lit by a large lamp that hangs down from the (unseen) ceiling. An unopened milk container sits on the table across from Faux. It has a sculptural outline and casts a small shadow. It seems precisely and perfectly placed, almost like an object in a Giorgio Morandi still life.

But we do not get to linger on this image. The camera continues panning past Faux. The next thing we see is a

coffee-table aquarium. We hear the water burbling and
see fish swimming back and forth. Past this, the camera
moves across a bedroom area, with a toy stuffed dog on a
night table next to the bed, and a window on the far wall.
Faux enters the frame from the right and sits down on the
bed; we see her in profile as she lip-syncs the lines about
giving up. As the music moves on to the first verse proper,
the camera once more leaves Faux behind. It pans across
a stretch of wall with pictures and then past a door with
venetian blinds drawn over a glass upper pane. Now we
reach the kitchen area. Potted plants grow on the counter,
to the left of a double sink. There are no dishes in the sink,
but the water is on. To the right of the sink, there is an elec-
tric range with food cooking on one burner. After this,
there is another stretch of counter with a coffee maker on
it; the pot is almost empty, and a red warning light is blink-
ing. The counter also contains several framed photographs
of Faux with another person whose face has been scratched
out. Past the kitchen, we return to where the shot began:
the TV on its table. The camera has made a complete cir-
cle, and now its motion stops. The bass player on the TV
raises his head and gives us a startled look just as the first
verse of the song ends. We see this glance for less than a
second; then the TV set clicks off, and we have a cut.

As the second verse begins, so does the second 360-
degree pan. It starts in the same place and moves in the

same circle as before. This time, the TV set is off, and the camera's light is reflected on its blank screen. The house lights, which were on during the first pan, are now mostly off. As the camera pans across the semidarkness, it picks out images as if with a searchlight. Many of the apartment's details have degraded, compared to the previous pass. For instance, the wall phone is off the hook, and the aquarium is empty, with the water no longer circulating. Some of the potted plants on the counter have been overturned. The sink is full of dirty dishes, as water flows unheeded from the faucet. On the range, food is cooking on all four burners, but several of the pans seem on the verge of boiling over, with nobody there to pay attention. In the photos on the counter, Faux's own face is now scratched out, together with the face of the other person. In the dining area, as Faux once more lip-syncs, she stands impassively and pours milk into the coffee cup, oblivious to the fact that the milk has overflowed, so that it streams across the table and drips down onto the floor. When we get to the bedroom, the stuffed dog on the night table has fallen over. Even as Faux continues to lip-sync, she slumps onto the bed, looking utterly ravaged.

In the third 360-degree pan, accompanying the third verse of the song, things are even worse. The TV clicks on to show Faux lying on the ground, apparently dead, with blood all across her chest and oozing out onto the floor.

The wall phone is still off the hook; it now issues a loud "no connection" signal. In the dining area, there is no sign of Faux, but the milk carton floats by itself in midair, still pouring milk into the overflowing cup. The aquarium has been completely trashed. In the bedroom area, the stuffed dog lies prone, next to a lamp that has been knocked askew. Faux lies miserably in the bed, under the covers, without the energy to lip-sync as she did before. Red and blue police lights flash throughout the apartment, from out the window.

At this point, the instrumental coda begins, although the camera has not completed its third rotation. There are more signs of damage everywhere. The plants on the counter have all been overturned and their pots broken. The sink is piled with even more dirty dishes than before; this time the faucet is off, but we see and hear flies swarming over it all. On the range, the burners are still on with food boiling over, but we also see a pot and a colander suspended in midair by themselves, angled askew. The photos on the counter have now been completely scratched out. The almost-empty coffee pot blinks its red light and beeps urgently. When we finally get back to the TV set, it shows us a close-up of Faux lying in bed. She seems to hear something and violently jerks her head to the side. The camera makes a quick pan—left or counter-clockwise, in the opposite direction from how it had been

moving previously—to arrive at the door with the glass pane covered by venetian blinds at the same time that Faux does.

From here on, everything changes. Faux pulls up the blinds, and we look out with her to see an enormous walking double bass, well over twenty stories tall, striding toward Faux's building (which we first saw from the outside in the opening shot of the video). We don't see either the head or the legs of this creature, but it has two long, articulated humanoid arms. In size and gait, it is a lot like Godzilla and the other monsters in Japanese films of the 1950s and subsequent decades. It is perhaps worth noting that the building and the bass monster are not just CGI effects (and therefore not just a metaphor): the former is a physical miniature, and the latter is a puppet (Munday). In any case, the video cuts between shots of the monster bass and reverse close-ups, from the outside, of Faux looking fearfully through her window. At one point, the camera quickly zooms out and away from the window, so that we get a vivid sense of how tiny Faux's apartment is, compared to the monster. Finally, just as the music ends, the monster grasps the apartment building in its arms and pulls it down. The video ends with the monster stumbling and then righting itself, as smoke and dust rise from the rubble. We hear the monster roaring and the building crashing and settling. At the very end, we also hear the

sound of helicopters in the distance, implying that help is belatedly on the way.

What can we make of this absurd catastrophe? López Estrada says in an interview that the video (like the song itself) is about "heartbreak" and that it progresses from our being a "passive observer" of Faux's plight to our being absorbed into Faux's own depressive point of view, which "amplifies and exaggerates the reality around her" (Munday). The formal repetition of the circular pan implies closure, while the deterioration from each pass to the next implies an arrow of time that points toward increasing pain and increasing entropy. But the video also lives in the close details that we pick up by watching carefully: the milk carton, the aquarium, the potted plants, the stuffed dog, the scratched-out photos. Each of these objects suffers its own weird metamorphosis or destruction. Kari Faux—which is to say, her persona in this song—is trapped in her own narrow space, with nowhere to go. Faux's apartment does not offer her protection from the outside; if anything, it seems to be the very point at which all of the outside's dangers and pressures converge. There are times when you feel like this, when you cannot hide or get away from yourself, and the only possible outcome seems to be for the world itself to implode. Of course, this does not really happen; the world goes on, without paying any special attention to you.

The rampaging double bass at the end of the video brings all of this together. The catastrophe is the culmination of everything that has come before, and yet it is also the thing that finally puts an end to Faux's suffering. At the same time, the grandiose absurdity of this vision of destruction pulls us away from the harrowing suffocation of the singer's plight. We return to the very beginning of the song, when the double bass plucked out, one note at a time, the musical line that defines "Fantasy." In this way, the monstrous, ridiculous apparition allows Kari Faux, the artist, to step free of the persona she created for the song. Indeed, López Estrada has done something like this before. In his 2015 video for Thundercat's "Them Changes," he presents the musician (a bass player, it might be worth noting) as a samurai whose arms get cut off in battle and who ends up sitting on a living-room chair and shedding a quiet tear as he watches a schlocky TV ad for the very sword that did him in. Both videos use their extravagantly absurd conclusions in order to tug us away from the grief expressed in the songs—but without negating this grief. Misery and goofiness come together in a strange alchemical combination. It's ridiculous to feel this way—and yet we do; we can't help it. The video supplements and intensifies the song and gives us an experience that could not have been expressed any other way.

ACKNOWLEDGMENTS

I have been interested in music videos for a long time. I am old enough to remember seeing MTV when it first went on the air in August 1981. I haven't been writing about music videos for quite as long, but still it's been a decade and a half since I first did so. However, this is the first time that I have ever written a whole book about music videos.

Above all, I would like to thank Carol Vernallis for her help with this book. She is the premier academic researcher on music videos; I have gained much from her friendship, from her own two books on music video, from her virtual visit to my classroom, and from all the feedback she has given me.

I would also like to thank all the students in my Wayne State University undergraduate class on music videos: English 5060, during the fall semester 2014. I can honestly say that this was the best and most fulfilling class I have ever taught, in three and a half decades of university teaching. The students were smart, enthusiastic, and helpful as we explored the history and the artistry of music videos together. I learned a lot from my students in this

class; they continually offered new perspectives, not to mention bringing in music videos for discussion and study that I had never previously seen or known about.

I would also like to thank the four music video directors who generously took the time to make Skype visits to the class, in order to talk to us about their work: Hadaya Turner, Jean-Claude Billmaier, Grant Singer, and Joseph Kahn. And finally, I would like to thank Gwendolyn Audrey Foster and Wheeler Winston Dixon, who solicited this book for the series Quick Takes: Movies and Popular Culture, which they are editing for Rutgers University Press.

FURTHER READING

Austerlitz, Saul. *Money for Nothing: A History of the Music Video from the Beatles to the White Stripes*. New York: Continuum, 2007.

Beebee, Roger, and Jason Middleton, eds. *Medium Cool: Music Videos from Soundies to Cell Phones*. Durham, NC: Duke University Press, 2007.

Goodwin, Andrew. *Dancing in the Distraction Factory: Music Television and Popular Culture*. Minneapolis: University of Minnesota Press, 1992.

Hillsabeck, Burke. "Accidental Specificity: Modernism from Clement Greenberg to Frank Tashlin." *Lola* 4 (Sept. 2013). http://www.lolajournal.com/4/tashlin.html.

Kaplan, E. Ann. *Rocking around the Clock: Music Television, Post Modernism, and Consumer Culture*. New York: Routledge, 1987.

Vernallis, Carol. *Experiencing Music Video: Aesthetics and Cultural Context*. New York: Columbia University Press, 2004.

———. *Unruly Media: YouTube, Music Video, and the New Digital Cinema*. New York: Oxford University Press, 2013.

WORKS CITED

Adorno, Theodor. *Aesthetic Theory*. Trans. Robert Hullot-Kentor. Minneapolis: University of Minnesota Press, 1998.

Allie X. Tumblr page. 1 Feb. 2015 http://xartxhibit.tumblr.com/.

Austerlitz, Saul. *Money for Nothing: A History of the Music Video from the Beatles to the White Stripes*. New York: Continuum, 2007.

Bazin, André. *What Is Cinema?* Trans. Timothy Barnard. Montreal: Caboose Books, 2009.

Beckett, Samuel. *The Unnamable. Three Novels: Molloy, Malone Dies, The Unnamable*. New York: Grove, 2009. 283–408.

Bolter, Jay David, and Richard Grusin. *Remediation: Understanding New Media*. Cambridge, MA: MIT Press, 2000.

Bordwell, David. "Birdman: Following Riggan's Orders." David Bordwell's website 23 Feb. 2015. http://www.davidbordwell.net/blog/2015/02/23/birdman-following-riggans-orders/.

———. "Intensified Continuity: Visual Style in Contemporary American Film." *Film Quarterly* 55.3 (2002): 16–28.

Butterfield, Aaron. "Dawn Richard—Blackheart (Album Review)." *Breathe Heavy* 20 Jan. 2015. http://

www.breatheheavy.com/dawn-richard-blackheart
-album-review.

Carter, Jayson Edward. "About Jayson Edward Carter."
http://www.jaysonedwardcarter.com/about.

———. Flickr page. 31 July 2016 https://www.flickr.com/
people/jaysoncarter/.

Cavell, Stanley. *The World Viewed: Reflections on the Ontol-
ogy of Film*. Enlarged ed. Cambridge, MA: Harvard
University Press, 1979.

Chion, Michel. *Audio-Vision: Sound on Screen*. 1990. Trans.
Claudia Gorbman. New York: Columbia University
Press, 1994.

Cinemetrics: Movie Measurement and Study Tool Data-
base. 10 July 2016 http://www.cinemetrics.lv.

Deleuze, Gilles. *Cinema 1: The Movement-Image*. Trans.
Hugh Tomlinson and Barbara Habberjam. Minneapolis:
University of Minnesota Press, 1986.

———. *Cinema 2: The Time-Image*. Trans. Hugh Tomlinson
and Robert Galeta. Minneapolis: University of Minne-
sota Press, 1989.

———. *Difference and Repetition*. Trans. Paul Patton. New
York: Columbia University Press, 1994.

Deleuze, Gilles, and Félix Guattari. *Anti-Oedipus: Capitalism
and Schizophrenia*. Trans. Robert Hurley, Mark Seem,
and Helen R. Lane. Minneapolis: University of Minne-
sota Press, 1983.

Dixon, Tim. "Paul Sharits—N:O:T:H:I:N:G." *Open File*
(blog) 7 May 2012. http://openfileblog.blogspot.com/
2012/05/paul-sharits-nothing.html.

Duboff, Josh. "Music Video Auteur Anthony Mandler
 Respects Miley Cyrus' 'Path' Even If It's 'A Little
 Distasteful and Adolescent.'" *Vanity Fair* 26 Dec. 2013.
 http://www.vanityfair.com/culture/2013/12/music
 -video-auteur-anthony-mandler-miley-cyrus.

Duffus, Paul. "Massive Attack, Tricky and 3D—'Take
 It There.'" *Pop Matters* 4 Feb. 2016. http://www
 .popmatters.com/post/massive-attack-tricky-and-3d
 -take-it-there-singles-going-steady/.

Eshun, Kodwo. *More Brilliant than the Sun: Adventures in
 Sonic Fiction.* London: Quartet Books, 1998.

Fineman, Mia. "Naked Ambition: Why Doesn't Spencer
 Tunick Get Any Respect?" *Slate* Jan. 2008. http://www
 .slate.com/articles/arts/art/2008/01/naked_ambition
 .single.html.

Fitzmaurice, Larry. "Video: Janelle Monáe: 'Cold War.'"
 Pitchfork 5 Aug. 2010. http://pitchfork.com/news/39658
 -video-janelle-monae-cold-war/.

Goodwin, Andrew. *Dancing in the Distraction Factory: Music
 Television and Popular Culture.* Minneapolis: University
 of Minnesota Press, 1992.

Greenberg, Clement. "Modernist Painting." *The Collected
 Essays and Criticism*, vol. 4, *Modernism with a Vengeance,
 1957–1969.* Chicago: University of Chicago Press, 1995.
 85–93.

Greenblat, Leah. "Kylie Minogue's New 'All the Lovers'
 Video: Naked in the Streets!" *Entertainment Weekly* 2
 June 2010. http://www.ew.com/article/2010/06/02/
 kylie-minogues-all-the-lovers-video.

Hansen, Mark, *Feed-Forward: On the Future of Twenty-First-Century Media*. Chicago: University of Chicago Press, 2015.

Hargis, Holly. "Embracing Gender Narratives: A Textual Analysis of Cold War by Janelle Monae." Gender&LitUtopiaDystopia Wiki 2013. http://genderlitutopiadystopia.wikia.com/wiki/Embracing_Gender_Narratives,_A_Textual_Analysis_of_Cold_War_by_Janelle_Monae.

Hoard, Christian. "Artist of the Week: Janelle Monáe." *Rolling Stone* 30 June 2010. http://www.rollingstone.com/music/news/artist-of-the-week-janelle-monae-20100630.

Hollywood Lexicon. "MTV Style Editing." 25 June 2016 http://www.hollywoodlexicon.com/mtvstyle.html.

Hunt, El. "So You Think You Know . . . Animal Collective," *DIY Magazine* 12 Jan. 2015. http://diymag.com/2015/01/12/so-you-think-you-know-animal-collective.

James, Robin. *Resilience and Melancholy: Pop Music, Feminism, Neoliberalism*. Alresford, UK: Zero Books, 2015.

Kant, Immanuel. *Critique of Judgment*. Trans. Paul Guyer and Eric Matthews. Cambridge: Cambridge University Press, 2000.

Kearney, Christine. "Kylie Minogue, Sexy as Ever on *Aphrodite*." Reuters 30 June 2010. http://www.reuters.com/article/us-minogue-idUSTRE65T53D20100630.

Leibniz, G. W. *New Essays on Human Understanding*. Trans. Peter Remnant and Jonathan Bennett. Cambridge: Cambridge University Press, 1996.

Manovich, Lev. *The Language of New Media*. Cambridge, MA: MIT Press, 2002.

Marks, Laura U. *Touch: Sensuous Theory and Multisensory Media*. Minneapolis: University of Minnesota Press, 2002.

Martins, Chris. "Watch Lana Del Rey's Bewitching, Surreal 'Shades of Cool' Video." *Spin* 17 June 2014. http://www.spin.com/2014/06/lana-del-rey-shades-of-cool-video-ultraviolence/.

Max, Josh. "2013 Chevrolet Malibu Drops 'Chick Car' Stereotype." *Daily News* 26 Feb. 2013. http://www.nydailynews.com/autos/latest-reviews/2013-chevrolet-malibu-drops-chick-car-stereotype-article-1.1273930.

McLuhan, Marshall. *Understanding Media: The Extensions of Man*. Cambridge, MA: MIT Press, 1994.

Metz, Christian. *The Imaginary Signifier: Psychoanalysis and the Cinema*. Trans. Celia Britton, Annwyl Williams, Ben Brewster, and Alfred Guzzetti. Bloomington: Indiana University Press, 1986.

Minsker, Evan. "Turn Off the Lights and Watch Animal Collective's Gaspar Noé–Directed Applesauce Video." *Pitchfork* 29 Jan. 2013. http://pitchfork.com/news/49342-turn-off-the-lights-and-watch-animal-collectives-gaspar-noe-directed-applesauce-video/.

Munday, Rob. "Carlos López Estrada Captures Heartbreak in His Cyclical Kari Faux Music Video." *Directors Notes* 27 July 2016. http://directorsnotes.com/2016/07/27/carlos-lopez-estrada-fantasy/.

Pagnani, Renato. "Allie X: Catch." *Pitchfork* 4 Apr. 2014. http://pitchfork.com/reviews/tracks/16834-catch.

Ramachandran, Vilaynur S., and Edward. M. Hubbard. "Synaesthesia—A Window into Perception, Thought, and Language." *Journal of Consciousness Studies* 8.12 (2001): 3–34.

Richardson, Mark. "Animal Collective: Interview." *Pitchfork* 18 Jan. 2009. http://pitchfork.com/features/interview/7585-animal-collective/.

Rickman, James. "Allie X Finally Made a 'Catch' Video and It Is Mind-Blowing." *Paper Mag* 22 Jan. 2015. http://www.papermag.com/2015/01/allie_x_catch_video.php.

Sharits, Paul. "Notes on Films/1966–68." *Film Culture* 47 (Summer 1969): 13–16. http://paulsharits.com/about-paul/about-films-by-paul/.

Shaviro, Steven. "Post-Continuity: An Introduction." *Post-Cinema: Theorizing 21st-Century Film*. Ed. Shane Denson and Julia Leyda. Falmer, UK: Reframe Books, 2016. http://reframe.sussex.ac.uk/post-cinema/1-2-shaviro/.

Singer, Grant. Skype interview with the author. 29 Sept. 2014.

Sitney, P. Adams. *Visionary Film: The American Avant-Garde, 1943–2000*. 3rd ed. New York: Oxford University Press, 2002.

Smith, William S. "A Concrete Experience of Nothing: Paul Sharits's Flicker Films." *RES: Anthropology and Aesthetics* 55/56 ("Absconding," Spring–Autumn 2009): 279–293.

Songfacts. "Let It Be." 15 May 2016 http://www.songfacts.com/detail.php?id=34150.

Sparrow. Tom. *Plastic Bodies: Rebuilding Sensation after Phenomenology*. London: Open Humanities Press, 2015.

Stork, Matthias. "Chaos Cinema [Parts 1 and 2]: The Decline and Fall of Action Filmmaking." *Press Play* 22 Aug. 2011. http://blogs.indiewire.com/pressplay/video_essay_matthias_stork_calls_out_the_chaos_cinema.

Syme, Rachel. "The Indivisible DΔWN." *Pitchfork* 22 Jan. 2016. http://pitchfork.com/features/interview/9795 -the-indivisible-dwn/.

Tunick, Spencer. Artist's statement. Spencer Tunick's website. 5 July 2016 http://www.spencertunick.com/ biography.

Vernallis, Carol. *Unruly Media: YouTube, Music Video, and the New Digital Cinema.* New York: Oxford University Press, 2013.

Vishnevetsky, Ignatiy. "What Is the 21st Century? Revising the Dictionary." *Mubi* 1 Feb. 2013. https://mubi.com/ notebook/posts/what-is-the-21st-century-revising-the -dictionary.

White, Armond. "Resurrection of Affection." *New York Press* 16 June 2010. http://www.nypress.com/resurrection-of -affection/.

Wikipedia. "All the Lovers." https://en.wikipedia.org/wiki/ All_the_Lovers.

———. "Lindsay Wixson." https://en.wikipedia.org/wiki/ Lindsey_Wixson.

Williams, Raymond. *Television: Technology and Cultural Form.* 1974. New York: Routledge Classics, 2003.

Wittgenstein, Ludwig. *Philosophical Investigations.* 4th ed. Trans. G. E. M. Anscombe, P. M. S. Hacker, and Joachim Schulte. Oxford, UK: Wiley-Blackwell, 1953.

Wolk, Douglas. "Head and Shoulders." *Fuse* 15 Nov. 2010.
http://www.fuse.tv/2010/11/head-and-shoulders
-janelle-monae.

Womack, Ytasha. *Afrofuturism: The World of Black Sci Fi and Fantasy Culture*. Chicago: Lawrence Hill Books, 2013.

YouTube. Comments on "FKA twigs—Papi Pacify." 13 Sept.
2013. https://www.youtube.com/watch?v=OydK91
JjFOw.

VIDEOS CITED

Allie X. "Catch." Jérémie Saindon, 2015.

Animal Collective. "Applesauce." Gaspar Noé, 2013.

Beyoncé. *Lemonade.* Beyoncé and Kahlil Joseph, 2016.

The Buggles. "Video Killed the Radio Star." Russell Mulcahy, 1979.

Del Ray, Lana. "Shades of Cool." Jake Nava, 2014.

———. "Shades of Cool (Director's Cut)." Jake Nava, 2014. http://mais.uol.com.br/view/wm36h76e4y14/lana -del-rey--shades-of-cool-directors-cut-04028C983370 E4815326.

Faker, Chet. "Gold." Hiro Murai, 2014.

Faux, Kari. "Fantasy." Carlos López Estrada, 2016.

Ferreira, Sky. "Night Time, My Time." Grant Singer, 2013.

FKA twigs. "Papi Pacify." Tom Beard and FKA twigs, 2013.

Jackson, Michael. "Thriller." John Landis, 1983.

Labrinth, "Let It Be." Us, 2014.

———. "Labrinth—Let It Be (Behind the Scenes)." YouTube 7 Sept. 2014. https://www.youtube.com/ watch?v=hFHS5X_KICU.

Massive Attack. "Take It There." Hiro Murai, 2016.

Minogue, Kylie. "All the Lovers." Joseph Kahn, 2010.

Monáe, Janelle. "Cold War." Wendy Morgan, 2010.

O'Connor, Sinead. "Nothing Compares 2 U." John Maybury, 1990.

Queen. "Bohemian Rhapsody." Bruce Gowers, 1975.

Richard, Dawn. "Calypso." Kytten Janae, 2015.

———. "Choices." Jayson Edward Carter, 2015.

———. "Not Above That" (lyrics video). Prefix Studios, 2016.

———. "Not Above That" (VR video). Monty Marsh and VR Playhouse, 2016.

———. "Tide: The Paradox Effect." We Were Monkeys, 2015.

———. "Wake Up." Sasha Samsonova, 2016.

Rihanna. "Bitch Better Have My Money." Rihanna and Megaforce, 2015.

———. "Disturbia." Anthony Mandler, 2007.

Sia. "Chandelier." Daniel Askill, 2014.

Thundercat. "Them Changes." Carlos López Estrada, 2015.

INDEX

Adorno, Theodor, 17
Affective expression, 35–36
Afrofuturism, 71, 102–103
Åkerlund, Jonas, 14
Allie X, 51–58
"All the Lovers" (Kylie
 Minogue), 86–94
Androids, 71
Animal Collective, 76–86
Animated GIFs, 55, 66, 96
"Applesauce" (Animal
 Collective), 76–86
Arca (Alejandro Ghersi), 59
Austerlitz, Saul, 4

Bazin, André, 11, 12
BDSM, 63
Beard, Tom, 59–67
Beatles, The, 1, 19
Beckett, Samuel, 109
Bellmer, Hans, 53
Bergson, Henri, 66
Berkeley, Busby, 2
Beyoncé, 6
"Bitch Better Have My
 Money" (Rihanna), 6
Black Lives Matter, 101

"Bohemian Rhapsody"
 (Queen), 1–2
Bolter, Jay David, and Richard
 Grusin, 72
Bond, James, 39
Bordwell, David, 24–25
Brecht, Bertolt, 82
Brown, Chris, 36
Buggles, The, 3
Buñuel, Luis, 53

Carter, Jayson Edward, 95–103
"Catch" (Allie X), 51–58
Cavell, Stanley, 9–10
Chevy Malibu, 39
Chien andalou, Un (Buñuel
 and Dali), 53
Chion, Michel, 8, 10, 33, 120
"Choices" (Dawn Richard),
 95–103
Cinematography, 12, 33–34, 56
"Cold War" (Janelle Monáe),
 67–75
Compositing, 25, 32–33
Continuity editing, 12, 14, 110,
 120, 122
Critical reflexivity, 82

Database aesthetics, 57
Deleuze, Gilles, 11, 25, 58, 66; and Félix Guattari, 11, 78
Del Rey, Lana, 38–50
Détournement, 53, 92, 98
Digital intermediate, 13–14
Digital media technologies, 6, 11–12, 25, 32, 56, 70, 82, 94
"Disturbia" (Rihanna), 27–37
Domino (Tony Scott), 119–120
DΔWN. *See* Richard, Dawn

Editing/montage, 12, 13, 25, 32, 33–34, 56
EDM (electronic dance music), 59–60
Eight-millimeter film, 30
Eisenstein, Sergei, 13, 31
Enter the Void (Gaspar Noé), 82
Eshun, Kodwo, 102

Fantasy (Kari Faux), 123–132
Faux, Kari, 123–132
Femme fatale, 118–119
Ferreira, Sky, 113–123
FKA twigs, 59–67

Godard, Jean-Luc, 12
Godzilla, 130
Gondry, Michel, 9
Goodwin, Andrew, 120
Greenberg, Clement, 79–80
Green screen, 77

Hansen, Mark, 112–113
Haptic film and video, 78
Hard Day's Night, A (Richard Lester), 1
Hawkes, John, 104–113
Heffington, Ryan, 108–109, 112
Hitchcock, Alfred, 12, 24
Hollywood musicals, 2–3, 7
Hypermediacy, 72–74

Iñárritu, Alejandro González, 24
Intensified continuity, 120

Jackson, Michael, 5; *Thriller*, 112
James, Robin, 36–37
Janae, Kytten, 97
Jazz Singer, The (Alan Crosland), 1
Jolson, Al, 1

Kahn, Joseph, 86–94
Kant, Immanuel, 81

Labrinth (Timothy McKenzie), 19–27
Leibniz, G. W., 16
Lemonade (Beyoncé), 6
Lens flare, 45–46, 88, 90
"Let It Be" (Labrinth), 19–27
Lip-syncing, 43, 53–54, 65, 69, 72–75, 114, 116
Long takes, 23–26
López Estrada, Carlos, 123–132
Los Angeles, 39–40, 42, 45, 86

Mad Max Fury Road (George Miller), 119
Madonna, 5
Mahoney, Mark, 38–50
Mandler, Anthony, 27–37
Manovich, Lev, 25, 57
Marks, Laura U., 78
Marsh, Monty, 97
Massive Attack, 104–113
Mayweather, Cindi, 71–75
McLuhan, Marshall, 3–4
Medium specificity, 79–80, 82–83
Melisma, 96
Metz, Christian, 32
Microperception, 16, 56, 58, 113, 123
Minogue, Kylie, 86–94
Mise-en-scène, 12, 33–34, 56
Monáe, Janelle, 67–75, 102
Morandi, Giorgio, 126
Morgan, Wendy, 67–75
Motion-control software, 23
MTV, 3, 5, 7; MTV-style editing, 119
Multi-process photo art, 97
Murai, Hiro, 104–113

Nava, Jake, 38–50
Neoliberalism, 9
"Night Time, My Time" (Sky Ferreira), 113–123
Noé, Gaspar, 76–86, 118
Nondiegetic space, 31–32, 62, 65, 77, 98–99

"Not Above That" (Dawn Richard) 97, 102
N:O:T:H:I:N:G. (Paul Sharits), 79–84
"Nothing Compares 2 U" (Sinead O'Connor), 68–69

O'Connor, Sinead, 68–69

Palmer, Laura, 114
Panoram Soundies, 1
"Papi Pacify" (FKA twigs), 59–67
Parliament/Funkadelic, 102
Perry, Katy, 96
Prefix Studios, 97
Proliferation of images, 33, 37
Proust, Marcel, 25
Psychedelia, 80–82, 100

Queen, 1–2

Replacements, The, 19
Representation, 35–36, 98, 112
Richard, Dawn, 95–103
Riegl, Aloïs, 78
Rihanna, 6, 27–37

Saindon, Jérémie, 51–58
Samsonova, Sasha, 97
Scopitone, 1
"Shades of Cool" (Lana Del Rey), 38–50
Sharits, Paul, 79–84

Shot/reverse-shot structure, 47
Silent Hill, 27
Singer, Grant, 113–123
Sitney, P. Adams, 79
SnorriCam, 42, 48
Soviet montage, 13
Stewart, Potter, 4
Stonewall uprising, 92
Stork, Matthias, 14, 120
Structural film, 79
Sun Ra, 102
Superimposed images, 40–41, 44
Surrealism, 51, 53
Swift, Taylor, 96
Synaesthesia, 78

"Take It There" (Massive Attack), 104–113
"Them Changes" (Thundercat), 132
Time-volume, 26
Transformers (Michael Bay), 119
Tricky, 105
Tunick, Spencer, 93–94
Twenty-first-century media, 112–113

Twin Peaks: Fire Walk with Me (David Lynch), 114

Us (Christopher Barrett and Luke Taylor), 19–27

Velvet Underground, 113
Vernallis, Carol, 13–14
Vertov, Dziga, 13
VHS tape, 30
"Video Killed the Radio Star" (The Buggles), 3–4
Virtuosity, 96
Vishnevetsky, Ignatiy, 9, 10
VR Playhouse, 97

Welles, Orson, 12
West, Kanye, 6
We Were Monkeys, 97
White, Armond, 92
Williams, Raymond, 5
Wittgenstein, Ludwig, 4
Wixson, Lindsey, 76–78
Wolk, Douglas, 68, 74
Womack, Ytasha, 102
Wörringer, Wilhelm, 78

YouTube, 6, 63–64

ABOUT THE AUTHOR

Steven Shaviro is the DeRoy Professor of English at Wayne State University. He is the author of books on film (*Post-Cinematic Affect*), on science fiction (*Connected, or, What It Means to Live in the Network Society*; *Discognition*), and on process philosophy (*Without Criteria*; *The Universe of Things*).